ART WORK
HOW PRODUCED
HOW REPRODUCED

ART WORK

HOW PRODUCED
HOW REPRODUCED

●

**THE MAKING AND THE
REPRODUCTION OF DRAWINGS
WATER COLORS, OIL PAINTINGS
MONOTYPES, BLOCK PRINTS
LITHOGRAPHS, ETCHINGS, ETC.**

EXPLAINED AND ILLUSTRATED BY
JOHN PETRINA

●

PITMAN PUBLISHING CORPORATION
NEW YORK

PITMAN PUBLISHING CORPORATION
2 WEST 45TH STREET, NEW YORK

ASSOCIATED COMPANIES
SIR ISAAC PITMAN & SONS, Ltd.
PITMAN HOUSE, PARKER STREET, KINGSWAY, LONDON, W.C.2
THE PITMAN PRESS, BATH
PITMAN HOUSE, LITTLE COLLINS STREET, MELBOURNE
SIR ISAAC PITMAN & SONS (CANADA), Ltd.
(INCORPORATING THE COMMERCIAL TEXT BOOK COMPANY)
PITMAN HOUSE, 381–383 CHURCH STREET, TORONTO

THIS BOOK IS INTENDED FOR

THE ARTIST

who should know how his work is, or may be, reproduced. Thorough knowledge of processes will enable him to produce his work in such a manner that it will not suffer through reproduction

THE ART TEACHER

who must understand how diversified types of work are produced and reproduced, in order that the student may be guided in the production and the appreciation of fine work

THE ART STUDENT

who needs to be informed as to the methods of producing and reproducing art work through the use of different media

THE LAYMAN

who may gain a better understanding and a finer appreciation of originals, prints, and reproductions

ACKNOWLEDGMENTS

Grateful acknowledgment is here given to Mr. Benjamin Franklyn Betts, A.I.A., Editor of *The American Architect*; Mr. Kenneth Reid, Managing Editor of *Pencil Points*; Mr. A. R. Gaydell, Art Director of the Sterling Engraving Company; and others for their permission to reprint art work which has appeared for them.

FOREWORD

PRATT INSTITUTE
BROOKLYN, NEW YORK

School of Fine and Applied Arts
James C. Boudreau, Director

Much has been written in the past presenting the various phases of graphic arts production and reproduction. However, not until Mr. Petrina gathered together the contents of this book has it been possible to obtain in one volume a complete range of media whose illustrations and text were produced by one person. This contribution is unique also in that all the illustrations, despite their great variation, are in every case works of art from the hand of an artist who has a range of media seldom if ever matched by his contemporaries. With this tremendous spread of techniques Mr. Petrina very fortunately couples simple, direct and lucid word pictures describing both methods of production and reproduction. Surely this happy combination of graphic illustrations and clear written descriptions is a real contribution to the literature of art. As this volume will testify, Mr. Petrina's value as a member of the faculty of the School of Fine and Applied Arts, Pratt Institute, has been outstanding. We are happy that he has found time in his very busy life to make available for a far greater circle at least one phase of his rich instruction.

James C. Boudreau
Director.

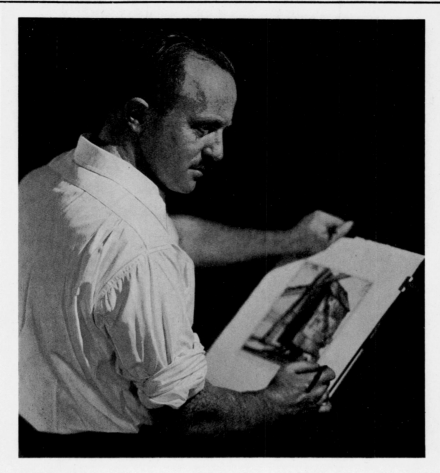

John Petrina

John Petrina's paintings, water colors, drawings and prints have been shown in the following exhibitions and museums: in France at the Salon des Artistes Français, and at the Salons Nationale des Beaux Arts; in the United States, at the Architectural League, The National Academy, Chicago Art Institute, Cleveland Museum, Pennsylvania Academy, and The Print Club of Philadelphia. His "Chapelle sur le pont, Avignon," was purchased by the French Ministry of Fine Arts for its National Collection—represented in the print collection of the Brooklyn Museum and in the New York Public Library.

The author of this book has illustrated for such well-known publishers and advertisers as *Harper's Bazaar*, the Crowell Publications, the Century Company, the *American Architect*, *American Girl*, *Pencil Points*, Japan Paper Co., the French Line, Canadian Pacific, Packard Automobile Company, and the Standard Oil Company. Some examples in this book are reprints of these illustrations, thus assuring the reader that the author is not only an artist in the fine arts, but has a clear and working knowledge of what is expected by publishers and advertisers.

CONTENTS

LIST OF ILLUSTRATIONS

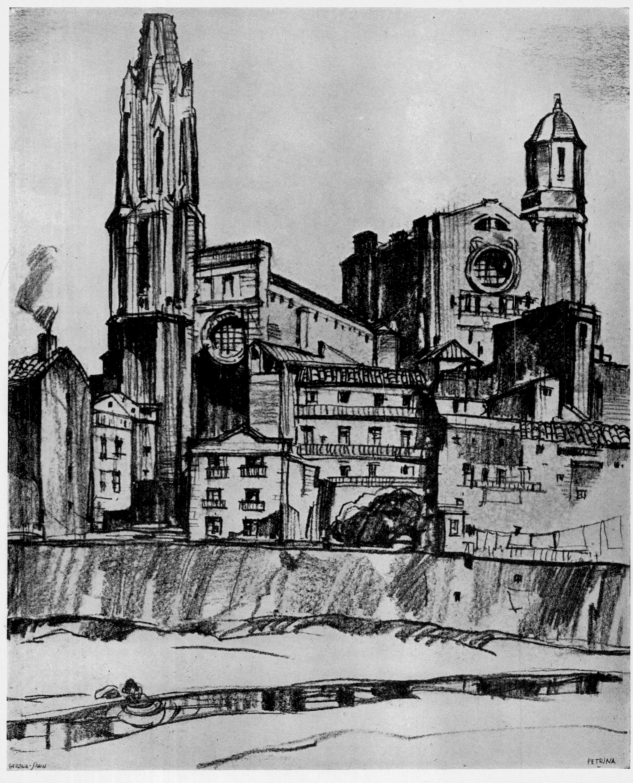

Gerona, Spain Pencil Drawing

PENCIL DRAWING

THE convenience and popularity of pencil as an artistic medium are indisputable. For the beginner the facility by which corrections can be made makes this medium particularly suitable.

Some of the pencil drawings in this book were made from the subject and others indirectly. The original of the small reproduction of Gerona, Spain (p. 2) was drawn on what is known as architect's detail paper and measures $9\frac{1}{2}$ in. by $12\frac{1}{2}$ in. It was drawn from a railroad trestle on location, which partly accounts for its unfinished state. From this a more definite drawing was made by placing over it a transparent parchment-like paper, intended for layouts, and on this a drawing with a 2B graphite pencil was made. Since this was virtually a tracing of the original, which could clearly be seen through the tracing paper, the lines have more assurance than the drawing from which it was made. This drawing was made permanent and darker by spraying fixatif composed of white shellac diluted in alcohol to the proportions of nine parts alcohol, one part shellac.

Size of drawing, subject, type of treatment, etc., all determine the surface of the paper and the degree of pencil to be used. Unless one has no doubt as to his ability, the approach should be made by drawing very lightly and with a comparatively firm pencil such as an H or HB. These preliminary or tentative lines are seldom objectionable if left on the finished drawing. Generally, they tend to remove hardness, and give the drawing a more spontaneous feeling. A soft pencil can be used on either a soft or firm surface, while with a harder pencil the artist is limited to the harder papers. Soft pencils are adaptable to freer and bolder effects. Harder pencils are more suitable for definition and accuracy. Bristol boards and Cameo papers are used both for fine line renderings and for broader and more painting-like treatments. The use of the stump on pencil drawings is something more for the experienced than for the beginner.

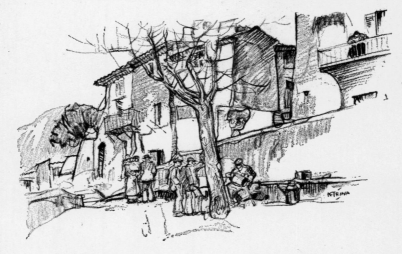

Tones handled directly with the pencil rather than with the stump are crisper. Generally pencil drawings are not suited for reproduction. The color of lead pencil cannot be closely approached by ordinary black printer's ink—that and the fact that graphite shines make it very trying to the engraver of the half-tone plates by which pencil drawings are reproduced. The reproduction on p. 2 is a 150-screen copper-plate half-tone. The reproductions on pp. 3 and 4 are half-tone reproductions with the whites dropped out by the Bassani process (see p. 95).

Corrections on pencil drawings can be made with either a soft eraser, or with a kneaded eraser, such as is used for charcoal drawing. The latter is preferable since it not only removes but absorbs the graphite. As in any other form of drawing, one should not depend on corrections, for they are bound to take away the vigor and directness, though of all mediums pencil is among the easiest to correct. In applying fixatif to pencil drawings, first, it should be blown very lightly and sparingly, then allowed to dry, and then a second spraying can be given. It is better to apply the fixatif twice than all at one time, for if all is applied in one spraying, there is a danger of wetting the drawing instead of dampening it, causing it to dilute the graphite and make a blur.

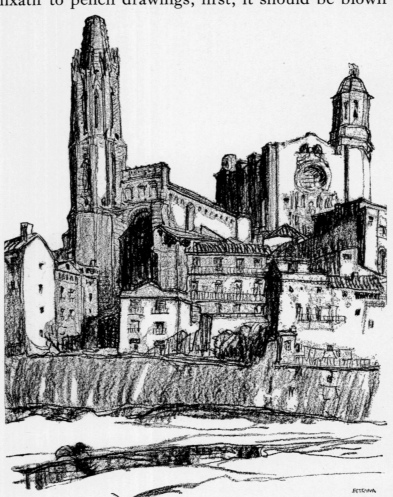

It is inartistic, if not unethical, to copy outright either from nature or from photographs without saying more than a photograph can say. However, the use of photographs, when not traced or copied, is permissible. Historical, foreign and other inaccessible subjects are more often than not rendered from reference material, including photographs.

A collection of reproductions of pencil renderings by

varied artists will help the beginner to see that there is no one treatment for any medium, including pencil, and that to express oneself in one's own manner is the only interesting way. The student should not allow himself to become influenced by the technique of any one person.

Texture of subject should also be considered; for instance, metallic or hard surfaces are represented by clean well-defined lines, while less tangible subjects, such as clouds and foliage, are treated in a freer manner. A finder consisting of a small frame made preferably of black cardboard can be of great help to the artist in locating a large pattern, so essential toward a good composition, from the subject he is to do. This finder will also act as a blinder and help to concentrate on one particular point of interest. Having visualized the proposed drawing, light outlines suggesting the contour can now be set down. These are the boundaries for the light grays which later can be intensified by darker values. The difficulty is not so much in adding, but rather in retaining the simplicity of the masses.

A tone scale kept in sight will assist in not breaking up the masses into too many values. A drawing which can be kept down to white, light gray, medium gray, and black, will be bigger in feeling than one which has all the realistic values of a photograph. When drawing shadows it is interesting to notice the reflected light (light in

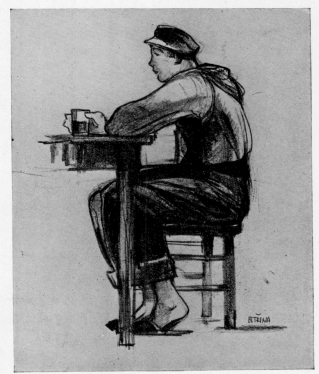

the shadows) and also the optical illusion which makes the darks next to the light seem darker. While values should be kept few and simple, large areas should vary a little, otherwise a feeling of flatness will be the result; this, and seeing that the rendering is not solid but handled with an occasional break in the lines, will give more crispness and life to the treatment.

For larger and broader treatments a comparatively soft pencil—a 3 or 4B—held in the palm of the hand will produce drawings of forced simplicity, a good practice for the timid draughtsman.

Being methodical helps one to produce better work. For pencil rendering one should always have within reach a sharp penknife, soft, hard, and kneaded erasers,

sand pads or a file to keep a desired point to the pencil, and an erasing shield such as used by draughtsmen can prove most convenient at times. The sharpening of the pencil at the right end, not the end which bears the grade mark, can save one much annoyance and time in selecting the pencils wanted. In conclusion, do not undervalue the merits of pencil because it is so well known to you or because of its limitations—all mediums have limitations and some do not have as many advantages as pencil.

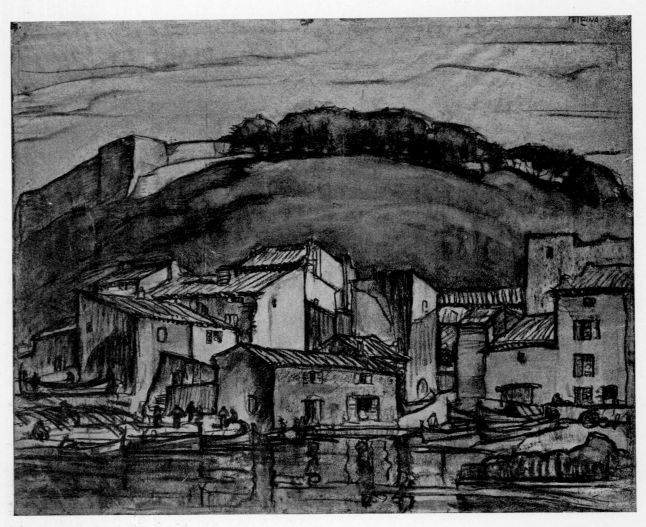

The Port, St. Tropez, France Charcoal Drawing

The above Charcoal drawing, "Port des Pêcheurs," measures in the original 17 × 21 in., and was made on cream-colored Charcoal paper directly on location. This is pure Charcoal, no carbon pencils having been used. The surface of Charcoal paper is more pronounced than the detail paper used in making the Charcoal drawing "St. Tropez." The fortification in the drawing is the citadelle or rampart of the little city.

CHARCOAL AND CARBON PENCIL DRAWINGS

DRAWING charcoal, to the French, Fusain, is generally made from the small Fusain tree whose twigs, when reduced by fire to charcoal, furnish the artist with an excellent drawing medium. Vines, when burned, also produce a soft and very thin charcoal stick. This is called vine charcoal.

The equipment for the making of charcoal drawings is extremely simple. Besides the charcoal, a chamois skin is necessary, for this removes the charcoal drawing from the paper far better than a cloth, and a piece of sandpaper, or a prepared sandpaper pad—or for permanency a file, to make a point to the charcoal when this is needed. A stump made of rolled chamois skin for broader blendings and one made of soft paper for closer work will prove handy. These stumps are kept clean and pointed with sandpaper. A kneaded eraser not only removes charcoal but also absorbs it, so that it does no harm to the surface near to where the corrections are made. As a substitute for this, a soft morsel of bread will work almost as well.

Because charcoal is a comparatively soft medium, it is best adapted for broader type drawings, which mean correspondingly larger ones in size. The hardest charcoal made will not give the fine detail that a hard pencil will give. On the other hand, when great detail is not necessary, charcoal gives one a pure, velvet-like black that for beauty cannot be surpassed by any other medium. That, and the fact that it takes to paper so readily, and at the same time can be so easily removed when changes and corrections are necessary, make charcoal as near perfect a medium as anyone can desire.

St. Tropez, France

A chamois skin removes charcoal sufficiently for ordinary corrections. When this is not sufficient, a soft eraser, or preferably a kneaded eraser which is really intended for charcoal, should be used. Since charcoal rubs very easily, one must not lose time in

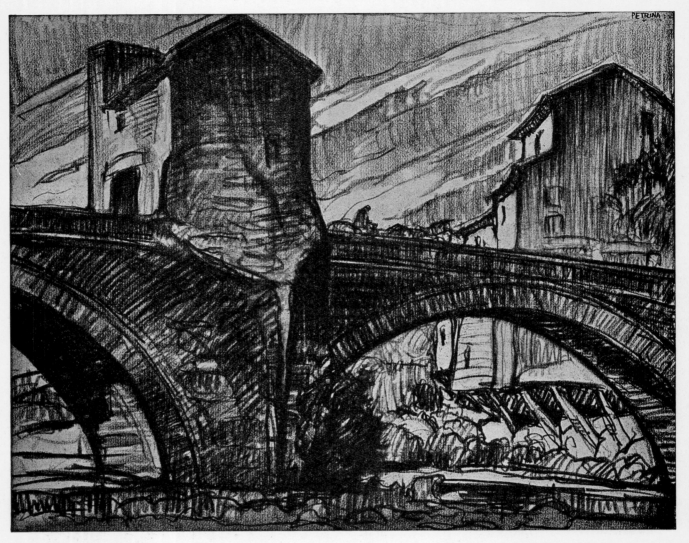

The Sospel Bridge, France Carbon Pencil Drawing

applying fixatif as soon as it is finished. When applying fixatif to a charcoal drawing the same rule as used for applying fixatif to pencil drawings should be observed—that is, not to apply so much at once as to cause the charcoal to become wet and run.

Charcoal paper should be tacked on a stretched canvas, particularly when large drawings are made. This makes it more agreeable to work on. By allowing two stretched canvases for this use, the charcoal drawing can be protected until finished (when the fixatif is applied) by facing the two canvases together and using separating pins—obtainable at artists' supply shops—between them.

Other than white paper can be used. Tinted or colored papers can be selected to be in harmony with the subject and treatment. A Fall landscape might possibly be more effective on a warm cream paper. A Winter subject could probably be improved in the use of a paper of a cold bluish tint, etc. When charcoal is used on papers of a deeper tone, and a touch of white with chalk or crayon is added (see p. 12), a charcoal drawing can become something colorful.

One need not limit oneself to the so-called charcoal papers, such as Michallet and Ingres, when drawing in charcoal, for almost any paper with a tooth or grain is good for charcoal.

Charcoal is now also made up in pencil form, in three degrees—soft, medium, and hard. This is a convenient form for the finishing of a charcoal drawing where a clean, definite line is required. For the large masses, the sticks remain the best. Most of my charcoal drawings are made without the aid of these charcoal pencils, although on some occasions I have found it necessary not only to use charcoal pencils, but to seek even more than a charcoal pencil will give in the way of a hard, clean line. At such times I have drawn these particular parts with a hard carbon pencil, leaving the charcoal for the stronger and heavier effects.

Shellac, very highly diluted in alcohol, makes a good fixatif. White shellac is usually used, but when a drawing has been made on a white paper and the artist feels that a warm tint over it would be an improvement, denatured alcohol with a little brown shellac applied with a blower will act both as a fixatif and as a means of toning the paper. One should bear in mind that this is more suited if the drawing is not to be reproduced, because any tint or tone will reduce the intensity of the whites and neutralize the drawing to a point where, when further neutralization takes place, as in making the plates for reproduction, the final effect will present a lack of contrast and the reproduction will seem flat.

Old Street, Avignon, France

Carbon being a firmer medium than charcoal, more definition is possible with it. Charcoal papers are very adaptable to it, but because this medium is harder, it

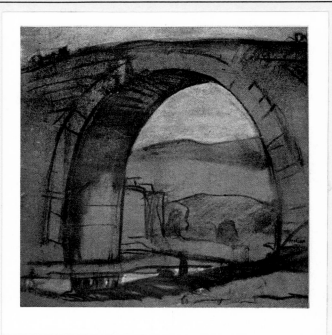

Spanish Bridge

penetrates the surface of the paper and consequently corrections are not as easily made as in charcoal.

Charcoal being softer is better for tonal and atmospheric effects, while carbon is more suited to the more tangible objects, architecture, etc.

While carbon does not rub as easily as charcoal, both require fixatif—which should be applied as soon as the drawing is completed, but not until then, for once the fixatif is on, corrections and additions are exceedingly difficult to make.

Carbon comes both in pencil and stick form. For small, fine work, pencil is better; for larger and broader work, the carbon sticks which can be used on the point or on the side are preferable. By using the carbon on the side, a wide line is produced in one stroke, and a drawing can be accomplished with more directness. The carbon drawings in this book were made half as large as the charcoal.

Whether our charcoal or carbon pencil drawing is intended for realistic, imaginative or decorative compositions, simplification, which means better drawing and fewer details, should always be the objective, telling one story at a time. Only one picture to a composition is a point not to be disregarded. Lines and values should lead up to the point of interest. Only by accident does all this exist ready made in nature, and generally, if not always, the artist must rearrange what is before him into a pleasing pattern. The drawings on pp. 8 and 9 are in charcoal, on pp. 10 and 11 in contè carbon pencil.

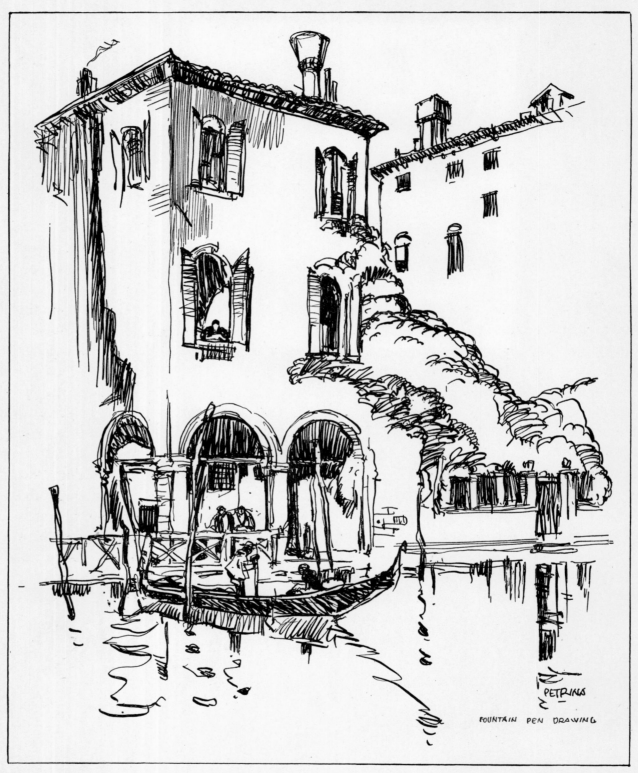

FOUNTAIN PEN DRAWING

The Traghetto

Pen Drawing

14

PEN RENDERING

PEN and ink drawings can be either pure line drawings, line with solid blacks, or drawings where values are obtained by regulating the number of lines and their intensity, or a combination of any or all of these styles. Line drawings and line with solid blacks are as safe for reproduction as brush drawings, and lose little in the usual reduction for the reproduction. Pen drawing with values, on the other hand, requires more thought and care, for when the reduction in the reproduction is too great, the white spaces between the lines are proportionately reduced and the result is that they fill in and become black. Pen drawings reproduced on ordinary paper such as newspaper and wood pulp stock, or for that matter, any soft uncoated stock, also run this risk of filling in, in the printing, unless care is taken that the lines are kept well open. Very fine "thin" lines are sometimes lost in making the plate, while a heavy line will become even heavier in the printing. For this reason a very pure medium black line is the safest.

Since pen, like pencil, is not an unknown medium, one need not acquire the confidence to use it. Confidence will more likely be needed in the drawing and in the preparation for rendering. Unlike pencil, which is extremely difficult to reproduce, a pen line, being a definite pure line in black, reproduces better than lines produced by most other mediums. The fact that the reproduction can be by line engraving, is an added inducement to its use, for line engravings are more faithful reproductions of originals than the half-tone; and since the pen line is more closely related to type face, a pen rendering when reproduced becomes part of the printed page.

Reproduction of pen work can be facilitated by the use of a rich jet black ink in the rendering. Prepared inks, particularly of the waterproof type, are excellent. The soluble inks are also good, though without the body of the former. Diluted and "thin" inks are to be avoided, for while, because of their softness, they may produce more attractive originals, certainly they are not dependable when drawing for reproduction.

While there are limitations to the inks one can use when working for reproduction, the type of pen to use is more of a personal matter. Obviously a fine line cannot be produced with a stub pen, neither in writing nor in drawing, but unless the pen rendering is of a very special kind, pen points used for

writing can be used in pen drawing. If anything, they are to be recommended to the beginner over the flexible and extremely sensitive pens, such as the Gillott's number 659 crowquill, the 291 Mapping and the 290 Lithographic, Gillott's 170, 303, and 404, or the pens one is already accustomed to, are quite adequate to begin with.

The use of a firmer pen as recommended to the beginner permits one to work on paper of almost any surface, excepting, of course, that it is not an absorbent paper, for in such case the ink line will spread. Nor is a paper with a pronounced grain practical, for this would arrest the freedom of the lines, or worse still, cause the ink to spatter. Writing papers such as bond paper take ink well—the disadvantage in the use of such papers over board being that, because of their thinness, corrections are difficult when not impossible. However, for practice and spontaneous sketching, writing papers are well suited. Waterproof ink, if used on very thin paper, contracts in the drying and will cause the paper to shrink. This is less likely when the "General" or soluble drawing ink is used.

Another paper not considered a pen and ink surface but on which pen renderings can be made (see reproductions on pp. 15 and 17) is tracing paper of a parchment-like quality, and because this particular paper is heavier than the usual, not only does it stay flat regardless of the kind of ink used, but it will also stand a great deal of punishment when corrections are necessary. Another advantage this paper has, over the boards intended for pen use, is that, being a tracing paper and therefore transparent, one need not redraw (assuming that the pen rendering is to be made from another drawing) but instead, by placing the paper over the well-defined pencil sketch, the tracing, which when finished will be the pen rendering, is done without harming the original. Having traced the essential lines as a start for the pen rendering —greater freedom is possible by removing the original from under it, and by finishing the pen rendering without further aid. Unless this is done, the result may prove an inanimate tracing instead of a direct pen rendering.

An unusual and interesting manner of applying color to a pen drawing made in this way, is to (preferably with crayons, since they are not moist) apply the color on the reverse side of the pen rendering. The result will be a delicate color (since it is seen through the paper) under positive pen lines.

When water color or washes are to be applied over pen lines, neither of the two papers described is advisable. Instead, a cold pressed board will be found far more satisfactory. If the pen lines are intended to blend with the washes, soluble India ink is used. When, on the other hand, the pen lines are intended to remain distinct, even after the color or wash has been applied, waterproof ink is preferable. A decorative treatment is possible by having a solid color come up to the pen line,

or again to run a water color wash over the entire pen drawing, and later, cut out the whites with opaque color.

The more accepted manner of producing a pen drawing is to first make a preliminary sketch, then work from the sketch to hot pressed or Bristol board, either lightly with a hard pencil, which gives a very fine line, or preferably with a light blue pencil. A blue line is not only less confusing—since the artist can then see more clearly the lines that will reproduce from the lines only intended to assist, but should these blue pencil lines be left when the reproduction takes place, no harm would come, for being blue in color they would not reproduce.

A pen rendering made over a careful pencil drawing will relieve the artist of much uncertainty and will enable him to concentrate more fully toward the actual rendering. A preliminary sketch will make the drawing more accurate, but a pen drawing made without the aid of a pencil sketch usually has more feeling.

Corrections on pen drawings are possible, but not desirable, for they certainly do not improve the appearance of the original even though they may not show in the reproduction. When some of the lines need to be removed, opaque, water color white, or a gritty ink eraser will do, but when a part of the drawing needs to be made over, the usual method is to glue (with rubber cement) a new piece of paper over the part one wishes to redraw in such cases, care being taken that the lines do not show a break at the edges. The patch itself will not show in the reproduction.

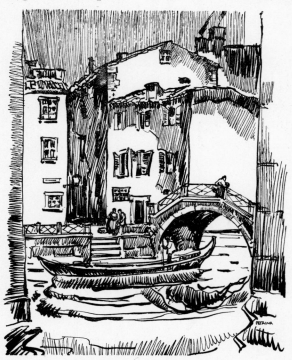

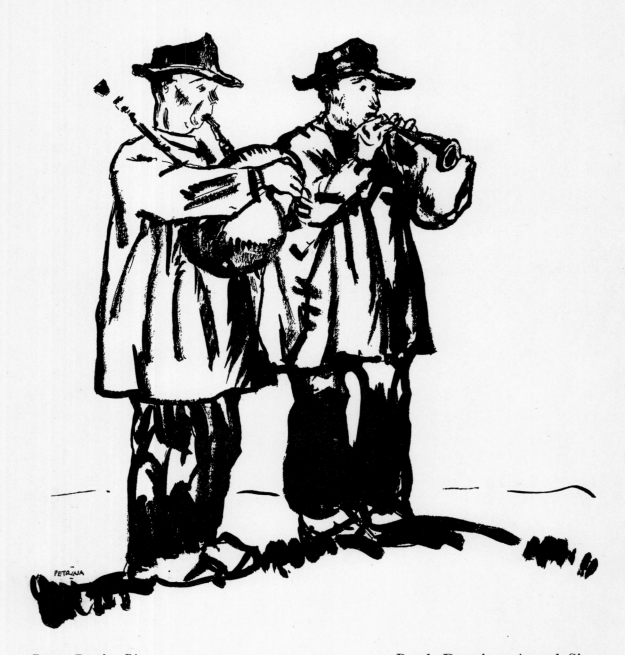

Breton Bagpipe Players Brush Drawing, Actual Size

BRUSH DRAWING

FOR reproduction, brush is an excellent medium. Brush allows the engraver to make line cuts which can be printed on varieties of papers, and the cost of a line cut, which can be made on zinc, is much less than that of a half-tone cut made on copper. It is better than a pen drawing, which can also be reproduced in line on zinc, because a brush line is not as delicate as a pen line, and therefore has more support from the body of the cut, and brush drawings, being usually broader, do not fill in as a pen drawing often does. Brush drawings have the further advantage over a pen drawing in the fact that, even though the surface of the paper may be hurt when corrections are made with a gritty ink eraser, the brush will draw over this surface in a way not possible with the pen. Brush drawings are freer and more spontaneous in feeling than a pen drawing, and can be made on any grade of paper, but preferably on paper that has some surface.

By a brush drawing is usually meant a drawing which is produced by a solid black brush line. A softer and grayer line can also be produced by using the brush half dry. This is known as a dry brush drawing. In a dry brush drawing some of the very fine dots that give the illusion of gray are often, if not always, lost in the process of having the reproduction made. However, the stronger dots are retained in the reproduction, and they create the effect of a half-tone. As in pen rendering, it is practical to use a light blue pencil in indicating what one plans to do with the brush. Corrections can be made either with an ink eraser, by painting over with white, or by pasting a clean paper over the place which one desires to do over. Naturally, corrections and patches do not help to make the original attractive, but, since we are primarily concerned with the reproduction, such methods can be resorted to when one has not the time to do the work over in its entirety.

When the surface of the paper is sufficiently rough, a lithographic crayon may be used to produce a grayness which can be reproduced by a line cut, or one can run light washes of blue where solid grays of different intensities are desired. Where it is indicated by the blue washes, a mechanical process known as Ben-Day is

applied (see p. 108). This will give the parts of the line drawing thus indicated an even tone, that, though mechanical in appearance, may improve the drawing considerably when used discreetly.

Brush drawings which are to be reproduced as such, and are not to have either color or black and white washes applied over them, can be done with soluble lamp black instead of waterproof ink. The lamp black is richer, softer, more velvet-like than waterproof India ink. It also dries faster and is grittier than India ink, and for this reason, very well suited for this type of brush work. Brushes used for dry brush work are not treated as carefully as when used for water color. In fact, when the brush is not worn, much is done to reduce it to this state by deliberately spreading the bristles on a blotter, thus dividing the brush so that many fine lines, which give the illusion of a tone, are the result of one brush stroke. While it is true that some of these very fine lines are lost in the process of making the engraving, on the whole, the appearance is not greatly affected. Certainly less than a half-tone reproduction affects a pencil drawing.

Charcoal paper is excellent for dry brush drawings. Its grain or "tooth" is just pronounced enough to pick up the ink or color, not too solidly, for even where deep blacks are desired, a less solid black, such as a rough surface will produce, becomes more penetrating, while a solid mass would actually be flatter in appearance.

When brush drawings are not intended for line reproductions, greater latitude is allowed the artist. Brush drawing, in this case, can be used as the basis for wash drawings, or water color renderings. A brush drawing made with waterproof India ink can, when dry, have washes of water color applied in a free manner, for the brush drawing will show through, giving support to what would otherwise be a too free rendering of color.

Another effective treatment of this medium is to first make the brush drawing with waterproof ink, then to apply an even water color wash in a half-tone (that is to say, a shade between black and white), and when this has dried, to paint in with opaque white, where white is wanted. The extreme simplification that is conducive by this manner of working, the fact that the representation is reduced to three values —white, gray, and black—makes a rendering of this type very decorative.

Porte de Samois, Moret-sur-Loing, France Water Color Painting

WATER COLOR PAINTING

TO the draughtsman who has attained proficiency in pencil, charcoal, pen and brush, painting in water color will be a refreshing note. While all the black and white mediums have their strong points, particularly where used for reproduction, they cannot be compared with the attraction color has, and particularly a clear, crisp water color. Water color, when well-handled, has more life, luminosity, and directness, than either oil or most any other form of painting.

For color painting, water color is no doubt the medium with the lowest cost, since the greatest use and waste will be water. Lots of pure clean water is needed, for unless the water used for the color and in the washing of the brushes be clean, the brilliancy of the medium will be seriously affected.

Next in line are the brushes—which when well-treated, will last indefinitely; therefore their cost depends on the care which they are given, because this will determine how they will last. At least one or two red sable brushes that will come to a perfect point are needed, for detail and smaller work. The larger brushes, better fitted for the broader work, need not be of red sable—and consequently can cost less. The colors should be the best, regardless of cost. In the end the best colors are very little, if at all, more costly than the poorer grades, which have not the brilliancy and do not go as far.

The papers—Whatman, Rives, Fabriano—are all excellent, but not necessary for the beginner. The examples in this book were not made on so-called water color papers. The "Breton Market Woman" was made on a cream architect's detail paper. "White House, Brittany," and "Town Gate Moret," were painted on charcoal paper. Spontaneous and direct sketches, as shown in this book, do not require studies and planning, but more complete work does. In such cases, two studies can first be made, one in pencil for the detail, and a color sketch for the color. This preparation will give the artist the assurance his finished work must reflect.

When the drawing for the rendering is made, which must be in outline, for shading would gray the color applied over it, this outline can be very light when it is not to be detected after the color is applied—or it can be deliberately bold and heavy when a more decorative feeling is desired.

The procedure in applying the color to the drawing is to a degree the reverse of painting in oil. In oil painting one works from dark to light, because over-painting

with a lighter color is possible. In water color, one has to work from light to dark, because the reverse would have no effect.

The brush which has been saturated with water (but must never be left in it) first dissolves the color in the pan, then blends it with other colors in the compartments in the box intended for this, and finally the color is applied to the drawing.

One method is to visualize the picture as one sees a stage setting. That is, to have definite patterns for the distance, the middle distance and the foreground, and the whole, in turn, to form a unit. Distance is represented by atmosphere, which means softer effects. Middle distance, by more definition and intensity, and the foreground by a still stronger pattern. Generally a dark pattern, running from edge to edge, will give the picture unity.

In painting from nature, one will notice how light will change the visual color of objects. Green in sunlight will be orange-green, in the shade blue-green, etc.

Light not only affects color but values. Black in sunlight is lighter in value than white in the shade. An outdoor photograph taken in sunlight will at once demonstrate this. Photography will also show us how any light object in sunlight will be lighter in value than the sky, while anything against the sun (even white) will be definitely darker than the sky. This is not meant as a suggestion that the student should try to copy Nature—something beyond the ability and the means of anyone. The best one can do is to make studies of impressions rather than the actual, and these studies which have little value except as such, can in turn be developed into creative work. In outdoor subjects, skies need not be represented as large unpainted surfaces. Dark skies not only dramatize a picture, but help to direct the interest to the lighter parts. In this manner, large areas of sky can be made to appear less empty. A most important point in water color painting is, that while it is possible to paint dark over light, one should always try to place the desired color without having to go over it to obtain it, for painting over in water color destroys transparency.

Larger brushes than a beginner is inclined to use are preferable. A number twelve sable brush and a half-inch and a three-quarter inch camel hair brush are not too large for water colors about ten by twelve in size, and since water color, like charcoal, is usually a medium best suited for a broad treatment, a water color should be correspondingly large. At any rate the suggestions I am making are the ones that, from my experience, I have found conducive to best results. In general, I believe that a beginner will benefit most by making a careful and slow drawing first, and by then applying the water color in a very direct manner.

Paper in water color painting plays a most important part. The most brilliant

effects are obtained on white paper, while unity and harmony can be more easily obtained on a half-toned paper. A very light cream paper is usually very pleasing, because it eliminates the glare from unpainted spaces.

Directness is one of the greatest charms of a water color. For this reason the more time spent in the planning and in the drawing, the less will be required for the painting, and more assurance will go into it. A water color must be handled fast and with confidence. A water color timidly handled is painful. While confidence and speed can only be reached through experience, careful planning and drawing will make it possible for the painter to concentrate on the rendering alone.

Because the water colorist works for directness, corrections are not only difficult, but seldom satisfactory. A fresh beginning is generally the solution when something goes wrong. When this situation is not willingly accepted by the artist, an attempt to save the water color can be made by using a sponge soaked in clean water to wash off the unwanted parts. The paper is then allowed to dry thoroughly, and, when dry, the repainting can take place.

Do not mix white or black—neither are colors, and both neutralize any color in which they are mixed. However, both can be very effectively used on their own, though the use of white in water color painting need not be necessary. Where whites are needed, they can be better represented by unpainted paper, or by erasing with an ink eraser. Small surfaces on a heavy paper can be scraped with a knife.

In rendering skies, it is often necessary to turn the drawing upside-down. This prevents the water color, which in such a case is usually applied very wet, to run to the lower part of the picture. Water colors always seem darker while wet, and allowances must be made for this, for otherwise the result will be weak and thin.

A little glycerine in the water will retard the drying, when this is desired. When drying is to be accelerated, use a little alcohol.

Colored drawings (see illustration) usually intended for a commercial use are rendered with either colored inks or coal-tar colors, which, although not considered as permanent as the regular water color, are much more brilliant and transparent. These colors stain the paper, and corrections when necessary are more difficult than ever.

Colors in tubes or half tubes are to be recommended over the colors in pans —though a water color box containing empty pans or half pans can well be kept filled from the tube colors, which, because they are air-tight, remain fresh indefinitely. Sometimes the caps of the tubes become difficult to unscrew—due to the fact that the color has hardened near the cap. This is easily overcome by applying a match and heating the cap until it turns.

The Market Place, St. Tropez A Colored Drawing

The better known water colors are Winsor and Newton, Cambridge and Rowney (English), Bourgeois, Lefranc (French). Some of the coal-tar colors are made by Schmincke and Talens. Only a few colors are needed to begin with: a yellow, Cadmium medium; a red, Vermilion; a blue, Ultra marine deep; a Viridian and a transparent red for the purples. Also a few earth colors for the tones, namely: Yellow Ochre, Burnt Sienna and Burnt Umber; and possibly, but not necessarily, a tube of Ivory Black, and a tube of White.

Coal-tar colors generally come in sets of a dozen or more pans. Do not treat these colors like ordinary water colors. They are infinitely more brilliant and intense.

For the reproduction of one-color renderings, commonly called wash drawings, half-tone plates are needed (see half-tone reproduction). For two-color renderings (one color and black constitutes a two-color rendering) two color plates and two printings are necessary.

On three or many color renderings, three or four plates, with the corresponding number of impressions in the printing, are required. For this type of reproduction see p. 95 under "Half-tone and Color Reproduction."

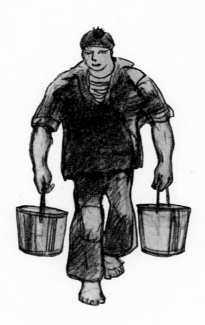

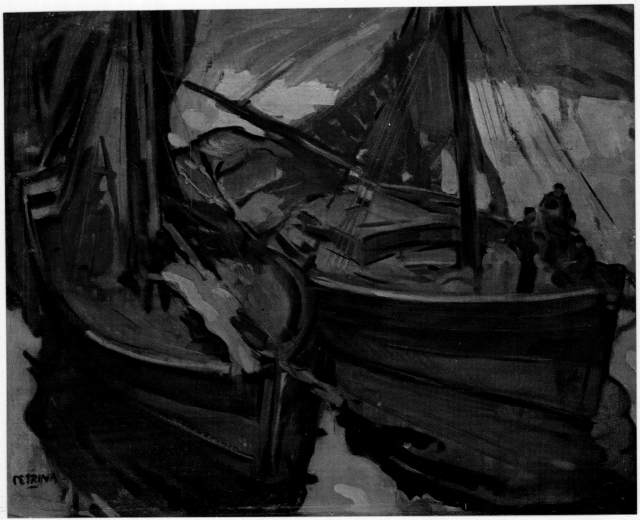

Fishing Boats, Honfleur, France Oil Painting

This study, made directly from the subject at Honfleur, France, was painted on unprepared cardboard treated with a coating of diluted fish glue. Liquid shellac or diluted fish glue makes any surface unabsorbent, and suitable for oil painting. Soft sable brushes need to be used when painting on such a surface, for the stiffer bristle brushes would not leave the color on the board. Poppy Oil and Turpentine were used as a painting medium.

OIL PAINTING

OIL painting can truthfully be called the medium of the beginner and of the master. With it the beginner can experiment and make no end of corrections without showing, in the result, traces of his efforts. Over-painting when properly done will in no way reduce the freshness so essential in a work of art. Because of this, the master, on the other hand, can obtain greater finish and depth than by any other form of painting.

Oil colors can be handled in many ways. They can be applied thinly for transparent effects, not unlike water colors. They can be used flat, and made to appear like tempera. They can be treated as a combination of these two methods, or they can be used in the accepted manner.

When used thinly, as transparent colors, they must be diluted with turpentine or oil, depending on whether they are wanted to dry mat or glossy. They must be used on a white base, such as canvas or prepared boards. When used to obtain tempera and flat effects, they must be thinned with turpentine or benzine—and the surface to which they are applied must be absorbent. Most untreated surfaces are absorbent. When used in their intended manner, that is, as a plastic medium, surface painting becomes the objective. For this a prepared surface is required, for the colors must remain on the surface. Very little mixing medium is used for this type of painting—for mixing mediums reduce the body of the color and prevent texture painting.

While canvas is the accepted surface for painting, it is not necessary to paint on canvas. Canvas is light in weight and, since it is usually sold ready prepared for the artist, it is used more than any other surface. Wood boards and pulp boards are heavier than canvas, but because of their flatness they do not require stretchers. Since they cannot be rolled, the pictures will never be cracked, for that particular reason. Stretched canvas "gives" a little and it is very sympathetic to the brush when color is applied, while boards are not as pleasing to paint on. The cheaper canvases are of cotton, and the better kind of linen. Linen is not only stronger, but it does not stretch like cotton, which has a tendency to sag. The selection of surfaces in canvases should be determined by the type of the painting. A very fine surface is better suited when extreme finish and detail is desired. A coarser canvas is more adaptable in larger and broader painting.

When beginning an oil painting, first draw very lightly with hard charcoal and

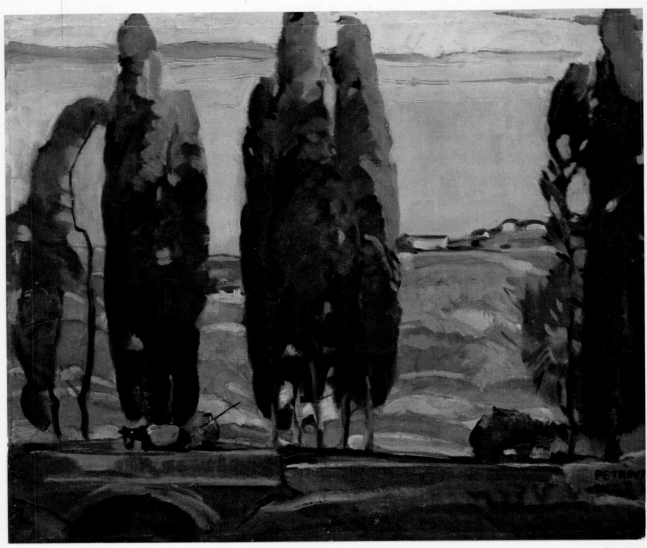

Cypresses Oil Painting

This sketch was painted in the South of France, on canvas glued to a cardboard. Painting Copal varnish and turpentine were used as painting mediums. This assisted in the drying, and made the painting possible in one sitting. The suggestion of a man and donkey was placed to animate the landscape.

then apply fixatif to it, before applying paint. In this way, the charcoal will not mix with the color and dirty it. It is advisable to lay in the picture very thinly at first, either with water color or very thin oil paint, for it is easier to paint and make corrections over thin paint than over heavily painted surfaces. Furthermore, values in plastic oil painting should be regulated not only by the gradation of color but also by the amount of paint applied; that is to say, darks, such as shadows, can have thin, almost transparent color, while light colors can be brought out almost in relief by applying more paint. This is called "impasto."

The painting in this book on p. 28 was painted on board. In its natural state, board, whether pulp or wood, is very absorbent, and if one were to paint without reducing this tendency the painting would seem more like "tempera" or "fresco" painting, because of its flatness. This can be overcome by applying a thin coating of diluted fish glue such as carpenters use, or diluted shellac. After this is done, a thin coating of white lead diluted with turpentine will make the board as white as canvas. This white lead should be allowed to dry thoroughly before the painting is begun. In this painting this was eliminated, the painting having been done directly on the board which had been treated with glue. Since a surface of this kind is usually very smooth, one must paint with soft brushes because a bristle brush will not leave the color as evenly on the board.

Painting in black and white—or monochromic painting (see illustration on p. 32) —can be a good approach for the beginner. This will postpone the problem of color until he has mastered the peculiarities of the medium. Incidentally, for work which is to be reproduced in black and white, it is safer not to paint in color—for some colors do not always reproduce in their true value, unless photographed with a special equipment. A little Ochre or Umber can be added to the black to take away its flatness. However, the safest method is to paint only in the colors in which the picture will be reproduced.

As soon as an understanding of the medium has been acquired, colors can be added, first red, then blue, and then yellow. With the three primary colors, black, which is not a color but the absence of color, can be eliminated, for when black is included, no attempt can be made to represent light by color, since light eliminates black. The combination of the three primaries gives the artist an unlimited color range. "Breton Market Woman" (p. 99), although a water color and not an oil painting, was reproduced by three colors, which in principle shows what range three colors can give.

Another method of painting is first to paint for values, as in monochromic painting, and when this first painting has dried, to apply glazes—that is, color made

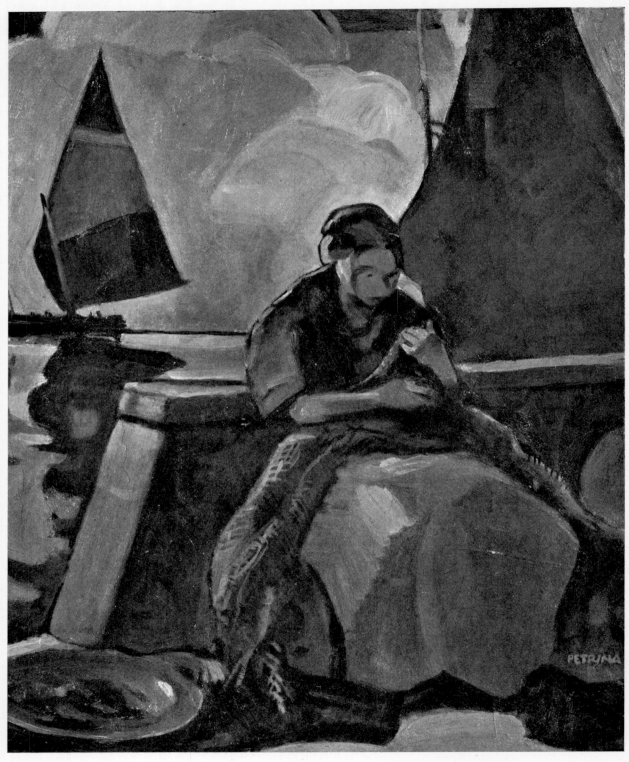

Mending Nets Oil Painting in Black and White

transparent by thinning with oil over the light parts—on the order that photographs, which are monochromes, are colored.

The more usual way is to paint the darks, but not the darkest first, then the light half-tone, then the lighter values or colors, and finally the lightest. Since one cannot go lighter than white nor darker than black, these two extremities should be held in reserve to the very last, and then not used unless needed.

Oil colors as they come in the tube are often uneven in their consistency, and should first be manipulated and equalized with a palette knife. The palettes (meaning the colors the artist uses) are as varied as the individuals who use them. It is such a personal matter that no rule can be given as to their arrangement. Some painters place the cold colors at one end and the warm colors at the opposite end. Others scale their colors, beginning with white, pale yellow, deep yellow, orange, red, purple, blue, green, and probably black, the Siennas, Umbers, and the Ochres and other earth colors being kept apart. Since their placing is such a matter of personal preference, the only advice is not to change their placing too often, for the painter must form the instinct of locating his colors, as though the palette were the keyboard of a piano.

The palette itself is generally made of light wood to fit into the paint box. It should be cleaned and oiled after each painting. With proper care, its surface in time will take on a patina that will be a joy to see. For studio use, a larger and excellent palette can be improvised by using the top of a small table—when doing this, the table can be placed before the easel, thus leaving the left hand free to hold the brushes. A few hours of painting will show why this is so convenient.

Glass, while less sympathetic than wood, makes a good surface on which to mix colors. A white board placed under a pane of glass makes the colors mixed on the glass show in their true value. Glass being non-absorbent keeps the colors fresh much longer than when they are mixed on an absorbent surface. The fact that paint does not readily dry on glass, makes a glass palette very easy to clean.

Painting brushes need not be the most expensive—except for a few red sables sometimes used in the finishing when extreme finishing is desired or required. However, they must be kept in good condition by washing after each painting with strong soap, and then thoroughly dried. Left unwashed, the very best brush will suffer. Next to brushes a most necessary accessory is a palette knife. This is not only needed for the palette, but for removing paint from the picture before making corrections. A more flexible knife, called "Painting Knife," is used both for removing paint from the picture and for applying color or painting with it. The use of a knife is often recommended when there is a tendency on the part of the artist to get

"muddy" color and to paint in a small manner. The use of wide brushes and a painting knife will counteract any inclination of overlooking the large patterns for the insignificant details.

Previously painted surfaces are more agreeable to paint on than new surfaces, but this is not always practical, particularly when the old painting was broadly done. In such cases, the brush marks of the old painting are sometimes apt to show where they are not wanted. Turpentine, linseed oil, poppy oil, etc.; any, or the combination of two or more, are used as painting medium—turpentine for a dull surface, and oil for slower but fresher drying. Drying can be further assisted by adding a fast drying varnish to the turpentine, in which case the dullness caused by the turpentine is overcome by the shine of the varnish.

When a picture requires more than one painting, the artist must decide on whether what he has done should dry or remain painting wet—something between these two points would not be satisfactory, for it would mean a "tacky" surface. The use of oil, particularly poppy oil, will keep the picture in painting condition overnight. The use of varnish in the turpentine will, on the other hand, dry the painting sufficiently to paint over on the following day. In painting over a dry painting, it is best to first rub the surface with thinned oil applied to either a cloth or a soft rag. This will help the successive work to blend.

It has been the practice to varnish finished pictures. While this does freshen them to a degree, it also destroys a certain quality of surface that one values who appreciates painting. By oiling a picture instead of varnishing it, one can get practically the same effect, and the oil will prevent cracking, whereas the varnish, being a fast drier, might have the opposite effect. Waxing is also used in giving painting a finish that is unequalled for its beauty.

For classification of oil colors and their permanency, see end of book.

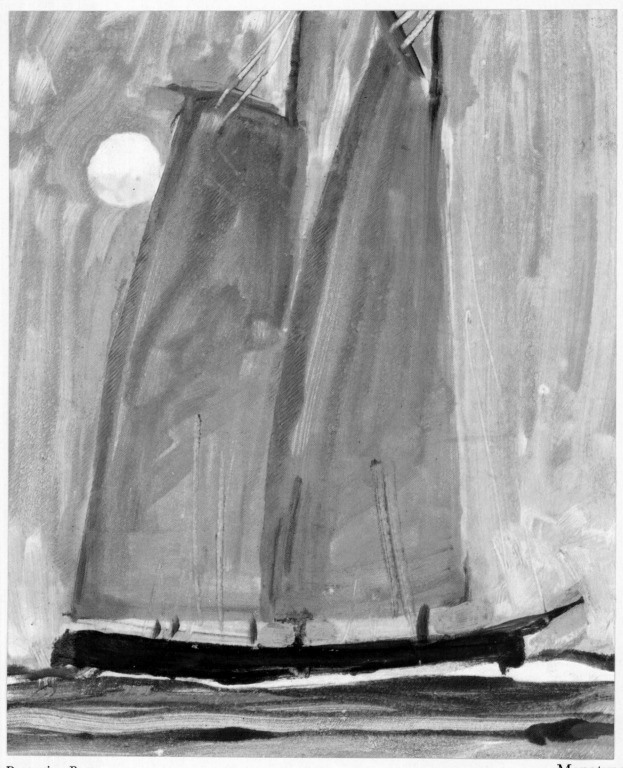

Decorative Boat Monotype

36

MONOTYPES

A MONOTYPE is a form of off-set or indirect printing from which, as its name implies, only one satisfactory proof can be pulled. The beauty of these prints is based on the fact that, because they are indirect prints, a certain softness and harmony is brought out which is difficult, if not impossible, to obtain by direct painting.

The painting may be made in oil on glass, metal, celluloid, or any other non-absorbent surface. Glass, because of its transparency, can be placed over a picture one wishes to convert into a monotype, and traced without harming the original. This is likewise possible when working on transparent celluloid, with the added advantage that celluloid does not break. Metal plates, on the other hand, are preferable when working directly on the plate. In order to obtain an even impression in the printing we must prevent the paint from drying before we are ready to pull the print, and that is why we paint on a non-absorbent surface. However, this alone is not sufficient to keep the paint fresh, and therefore we use a slow drying medium in our color, such as petrol, kerosene, or coal oil. Too much color on the plate will spread when pressure is applied in the printing, while too little color will result in a very thin print, because a certain amount of color always remains on the plate. In successful monotypes the color does not spread beyond the edge. To avoid this we paint more thinly there than in the center. Having completed our painting, striking effects can be obtained by wiping the plate clean where whites or near whites are wanted, provided the paper on which we print is white. Now we are ready for the printing.

The printing depends on the kind of plate we have used. If we used glass, great care must be given not to break it while pulling the print. Greater pressure may be applied in the printing of either a celluloid or metal plate, and a better proof can therefore be obtained. Monotypes from metal plates have one particular advantage over glass or celluloid prints, which is that a second print can be produced by slightly warming the plate after the first print has been pulled. This softens the paint, thus making a second print possible. The printing may be done by hand, but it is not as satisfactory as printing by press (an ordinary letter press may be used). As in all forms of printing, the paper should be softened by dampening, and in this case somewhat more absorbent paper should be used than papers intended for etching or lithography.

4—(E. 12)

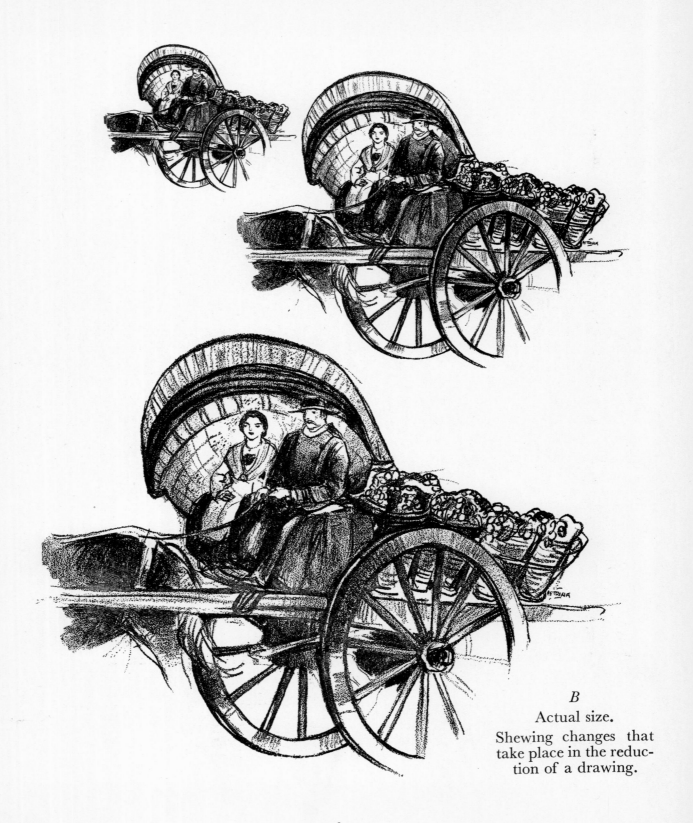

B
Actual size.
Shewing changes that
take place in the reduc-
tion of a drawing.

SURFACE PAPER

ONE need not depend entirely on the medium for unusual effects. The surface on which one works can, in many cases, do as much as the medium itself in producing interesting effects, and sometimes makes the reproduction more effective, while reducing its cost.

Line engravings are not limited to brush or pen drawings. They are limited only to the extent that no screen is used, and therefore the dots in the copy, or original, must be very distinct (see "Photo Engraving"). Sometimes the paper selected will have a grain which will produce this, or again this can be produced by using a thin paper over the desired surface. Drawing *A* was made by using a lithographic crayon on ordinary charcoal paper. This produced very definite dots and black lines which, because the grain of the paper was fine, created the illusion of a tone. This kind of a drawing can be produced as a line cut on zinc. Drawing *B*, on the other hand, was produced on a paper which has an especially grained surface intended for this type of work. This paper goes under so many names that it is useless to designate it by any one name. However, the actual size reproduction of work done on this paper (*B*) will show what the surface is like. This is the surface used a great deal in newspaper drawings, for when the drawing is not reduced too greatly, it reproduces very well on pulp stock. There are also other varieties of paper which give almost as many effects as Ben-Day. For instance, a surface board very useful to fashion artists is made with grains corresponding to textures and weaves of cloths, such as herring-bone, cross-hatch, etc. This makes it possible for the artist to rub on the surface either a lithographic crayon or blaisdell pencil, and produce textures without having to draw them or resort to the Ben-Day or other processes.

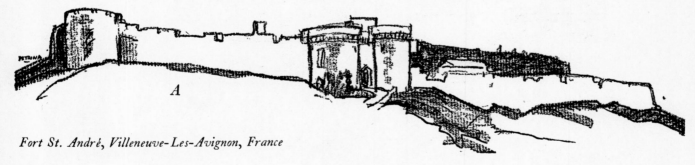

A

Fort St. André, Villeneuve-Les-Avignon, France

Choice of paper influences texture of lines, as shown in this lithographic crayon drawing on Charcoal paper.

39

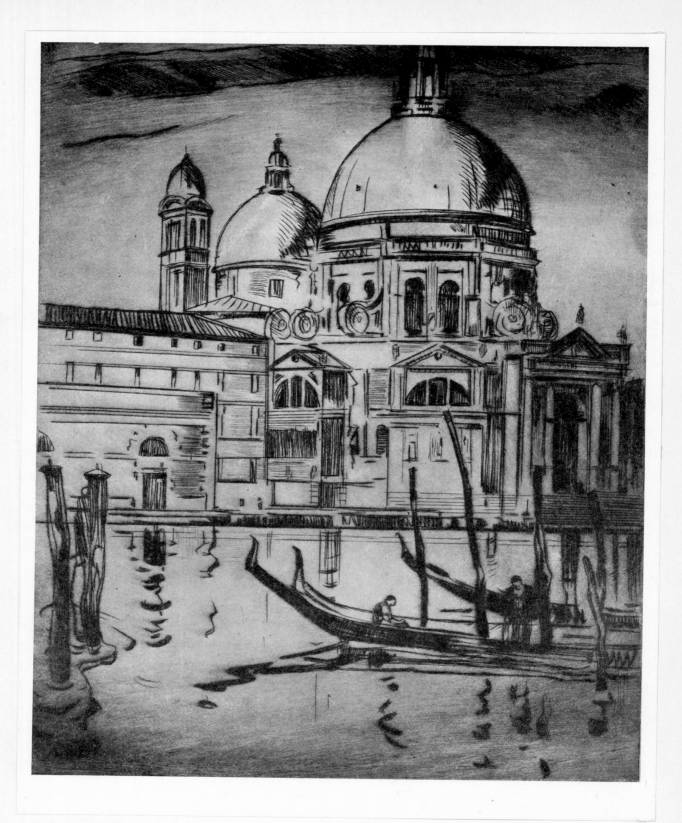

Grand Canal, Venice Celluloid etching

CELLULOID ETCHINGS

A CELLULOID etching is an excellent introduction to dry-point etching, for it will give the beginner an idea of what constitutes a dry-point. It is a dry-point in every respect except that it is not done on copper, zinc, or any other form of metal plate. In this type of etching the line is produced by intaglio (cutting into the surface) as in dry-point, or engraving.

A decided advantage of celluloid etching is the fact that, because celluloid is transparent, it can be placed over a drawing or photograph and a line scraped on the celluloid. When these lines are filled with ink, and the paper which has been softened by dampening is placed over the celluloid, and the printing takes place, a print which will have very much the same quality as an etching will result. Because this type of etching presents no difficulties of technique beyond, naturally, the ability to draw, practically no time is required to obtain satisfactory results.

Dry-point, soft ground, and even mezo-tint effects can be obtained on celluloid. In dry-point etching on metal the burr which is caused by cutting the line gives it its beautiful quality. Celluloid, being more brittle, does not give this burr, and therefore has not the charm of a real dry-point. On the other hand, the facility with which a so-called etching can be made in this manner, is such that not only interest but enthusiasm for prints is created by it. Soft ground effects are obtained by using the small blade of a sharp penknife, instead of a needle, as in dry-point effects, and by scraping a softer and broader line. Mezo-tint effects are possible by surfacing the celluloid with fine sandpaper, and then scraping and burnishing the surface entirely where whites are desired and moderately where half-tones are wanted.

Printing from a celluloid plate is in every respect similar to the printing of a real etching, except that the inking of the plate is a little more difficult, because it is not practical to warm the celluloid plate as is possible with a metal plate. Since we cannot draw the ink into the lines by warming the plate, it becomes necessary to some extent to soften the ink. Having inked the plate, the wiping, which determines the tone of the plate, needs to be considered. Some treatments show to better advantage when the plate is wiped clean. Others are enriched by leaving a certain amount of ink on the plate. For instance, a marine can be given color of tone by leaving some of the ink where water is suggested, or in a landscape more intensity can be given to the foreground by allowing a greater degree of the ink to remain there. If, however, one has drawn a beautiful line which one desires to keep intact, clean wiping may be preferable.

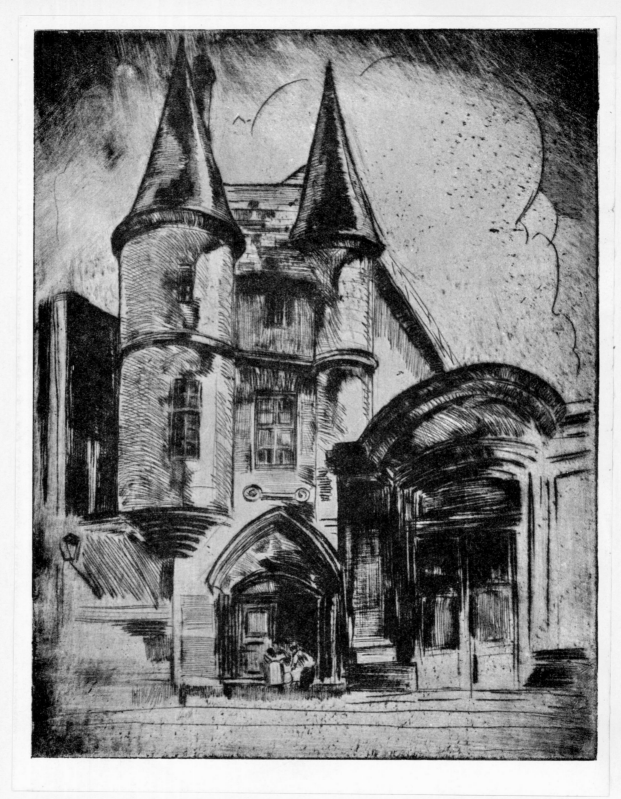

L'Hotel de Clisson, Paris A Dry-point

DRY-POINT ETCHINGS

ALTHOUGH a dry-point is more of an engraving than an etching (in fact the lines are not etched at all), it is more often than not referred to as an etching. The difference between a dry-point and an engraving is that in engraving no attempt is made to retain the burr produced when the line is cut. In dry-point this very burr is what gives the rich, velvety blacks which make it so distinctive. For this form of etching it is almost necessary to limit ourselves to copper, for a zinc plate, being softer, will give us so few proofs that the result will hardly justify the effort.

When a dry-point is made directly from the subject, it is advisable that the artist first sketch in the main lines of the drawing with something that will adhere to the surface, such as lithographic pencil or crayon. Again, the more planning done before the line is cut into the plate, the less likely is one apt to make mistakes, and in this medium, once a line is cut into the plate, the removal of it, when a correction or change is wanted, is a very tedious and long procedure of scraping and burnishing. For serious and careful work, preliminary sketching becomes necessary. These sketches can then be traced to the plate in various ways. One is by placing a carbon paper under the drawing between the drawing and the plate (carbon side facing the plate), and then going over the main outlines of the drawing with a hard pencil or point. This will leave an imprint on the plate sufficient to establish the basic lines.

A more indirect but no doubt a more satisfactory method is to ground or smoke the plate as in regular etching, and then either trace the drawing to the ground, which will hold it better than the untreated plate, or, if one is so fortunate as to have a press, place the pencil drawing face-down upon the ground, then place a damp blotter on top of the back of the drawing, and then run the three through the rollers of an etching press. This will not only transfer the drawing accurately, but will give one the tracing in the plate in reverse, which is necessary in order that the print will be like the original drawing.

The tools required for making a dry-point are not many. A small wet stone is absolutely indispensable. This is to keep the steel dry-point in perfect shape. One's finger-nail makes an excellent testing surface to see whether the point is sufficiently sharp. A large and a small steel point, a burnisher, and a scraper and some lamp black mixed with vaseline (to fill in the lines that have been cut and show the artist

43

what to expect) are the necessary implements. These can be supplemented with a burin, a diamond, or a ruby point.

Having drawn or traced the sketch in reverse to the plate, it is necessary that we see the original from which we are going to work also in reverse. This is done by looking at it through a mirror.

There are lines in a dry-point where the burr is not desirable. We must cut these lines first, and then remove the burr with a scraper. The great advantage that dry-point has over etching is the fact that progressive proofs can be made without having to reground, re-etch, etc., as in etching. However, since a dry-point is more delicate than an etching plate, and since the plate does not last as well, one must not overdo this. Diamond and ruby points do not give one as much burr as the steel point. However, they have the great advantage that they never need to be sharpened, whereas with a steel point the sharpening is practically constant.

The printing of a dry-point is definitely more difficult than the printing of an etching. However, the principle remains the same, that is, in the inking; we must try to get the ink into the lines and remove it from the surface. When a large edition is desired it is necessary to have the plate steel-faced. The steel facing, which is an electrical process, leaves such an infinitesimal layer of steel on the face of the plate that, though it increases the life of the plate many times, it in no way affects the appearance of the print.

The dark velvet-like tones in dry-point illustration on page 42 are caused by the burr.

In the Fall Soft Ground Etching

SOFT GROUND ETCHINGS

SOFT ground etching can be called etching while sketching, for the etching is made by drawing in ordinary pencil on thin paper over an etching plate which has been surfaced with soft ground. In straight etching, where the line is made by removing with a needle the smoked ground, thus exposing it to the action of the acid, the artist has no clear idea of his work until a proof is pulled. In soft ground etching the lines drawn on the paper with an ordinary pencil cause the paper to pick up and remove the soft ground by which the plate has been treated, and at all stages the drawing that is being made is clearly seen. Soft ground etching produces a line very similar to the pencil line by which it is made, with the same spontaneity and directness.

Soft ground is made by mixing ordinary etching ground with mutton tallow, in varying proportions, depending on the time of year. In the summer the ground naturally needs to be firmer and less tallow is needed, ordinarily about half tallow and half etching ground is the average proportion. For those who prefer not to prepare their own ground, Sands Soft Ground, prepared by John Sellers & Sons, is very good. The ground is applied to the plate as in straight etching—that is, the plate is thoroughly cleaned with whiting and water, the whiting removing any traces of dirt or grease from the plate, and the water removing the whiting. Having cleaned the plate scrupulously, we place it on a heater, and warm it to a point where it will accept the ground but not scorch it. The ground is equalized and thinned on the plate with a dabber, the aim being to apply sufficient ground to protect the plate when immersed in acid, but still to have it thin enough to be readily picked up by the pressure of the pencil upon the paper, when the drawing is made.

Now that the plate is prepared, a thin, absorbent paper such as that used in making layouts, and usually made up in what is known as art directors pads, is laid upon the flat surface of a drawing board or table. The coated side of the plate is placed face down on the paper, and the edges of the paper are folded back and glued, so that the paper will not slip. When the sketching is done on the paper, the pressure of the pencil causes the paper to remove the ground, thus exposing the plate where the drawing is made, so that this part of the plate can be attacked by the acid when the etching takes place. Since every line drawn on the paper causes the removal of the ground, and consequently makes a line on the plate, the sketch on the paper can previously be lightly suggested with a colored crayon, thus

enabling the artist to work with more assurance, when the actual drawing is made with the graphite pencil. Soft ground needs to be treated even more carefully than ordinary ground, it being sensitive to the slightest touch, and therefore we must work in such a manner that our hand does not rub or even touch the paper we work on. This may be accomplished easily by placing the top side of a T-square under the hand, making certain that enough space exists between it and the paper we work on. Should we accidentally touch and injure the

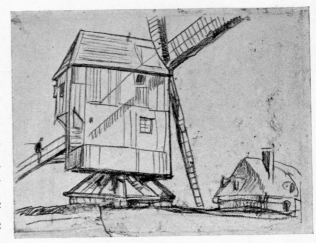

The Pencil Sketch, Reduced

ground, asphaltum or shellac will cover and protect the affected parts from the action of the acid.

Having reached this point, the biting with the mordant takes place. This can be done either by applying the solution with a feather or by first protecting the back of the plate with diluted asphaltum or shellac. Then place it in a tray, and either pour over it the prepared solution or pour first the water and then as much acid as is needed. By bordering the plate with bordering wax and building up the sides, a tray is made out of the plate itself. This last method is a solution for

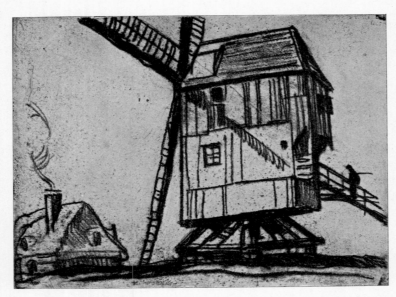

The Finished Print, Original Size

the unusually large plate. The strength of the acid solution depends on whether the plate is zinc or copper. Copper plates bite slowly, consequently a solution of about one-third nitric acid to two-thirds water is used. Zinc, being softer, requires a weaker solution, that is, about one-sixth nitric acid to five-sixths water. A few minutes after the plate is immersed in the acid, bubbles will appear. These bubbles show that the action of the acid is taking place, and since they interfere with even

biting, they should be brushed off with a soft feather. Exactly how long a plate should be left in the acid depends greatly on the kind of line which was drawn on the plate, and the type of line desired in the etching. Delicate lines and grays can be retained by taking the plate out of the bath, stopping out these lines with stopping out varnish after the plate has been washed in water, and by then replacing the plate in the bath, so that further action may take place on the lines to be strengthened. When the plate seems sufficiently bitten, it is removed from the bath, again washed in water, and both the ground and the asphaltum are removed with a rag soaked with turpentine. Unless one does a great deal of etching and is able to judge almost instinctively the timing of the mordant's action on the plate, it is safer to determine by timing the action on a separate small plate. By doing this one will know beforehand what to expect on removing the ground for the printing.

The printing of a soft ground is another problem, and something based more on experience than on knowledge. However, in a general way this is what happens: the plate is again slightly heated, the ink is then applied so that it will penetrate the bitten surface where the plate has been etched, the surplus ink is wiped off with a soft rag, a sufficient amount of ink being left on the plate if a tone is desired. A paper which has been previously softened by dampening is placed over it, blankets are placed over the paper, this is passed through the press, and we have a soft ground etching.

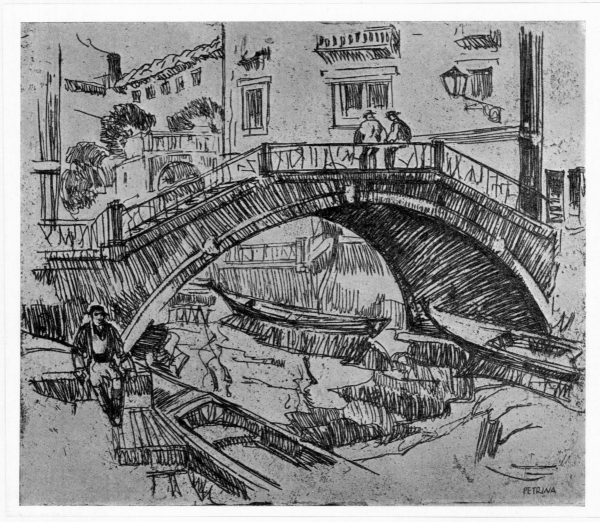

Venetian Bridge Straight Etching

This pure etching was made on a Zinc plate and is reproduced in the size of the original. It was made in two states (two bitings). In the first state the values of the building in the background and of the bridge were the same. After the first biting, the background was stopped out and protected from further action of the acid while the bridge was etched deeper and stronger. Just a little dry-point retouching (on the face of the figure) was added.

ETCHINGS

AN etching is a print made from a metal plate, on which lines have been etched by the action of acid. These lines absorb the ink, which in the printing is forced on to the paper by the pressure of the roller of the etching press.

Zinc and copper are the two most common metals on which an etching is made. The preliminary treatment of the plate is identical in either case. The plates need to be scrupulously cleaned before the ground is applied. The ground, which is a substance mainly containing wax, is applied to the plate after the plate has been slightly heated, so that it will receive it. Having applied the ground by a few touches of it on the plate, it is equalized and evenly distributed by a dabber or roller. The purpose of the ground is to protect all but the drawn lines from the action of the acid. What is meant by well-applied ground is when the ground on the plate has been applied thinly enough so that the needle will easily clear the lines, and at the same time thickly enough to withstand the acid. In applying ground to the plate, the plate must be warm, but not hot, for a hot plate will kill the elastic quality of the ground and cause it to become brittle and chip off.

Having ground the plate, a dull black finish can be given to it by smoking it. This will make the exposed lines more evident, and though it is necessary to become accustomed to seeing light lines on black, it is the most satisfactory way of working. White ground cannot be recommended.

There are many ways of transferring the drawing to an etching plate. One is to take a piece of celluloid, place it over the drawing one wishes to convert into an etching, scrape the major lines on the celluloid, rub powdered color into these lines, place this side of the celluloid facing the ground, and by giving the back of the celluloid light taps, the powdered color in the lines will go to the ground on the etching plate. Another method, is to place a transparent paper over the drawing

The Pencil Sketch (reduced) from which the print was made

51

that is to become an etching, make a tracing of it, dampen the tracing, and then place it face-down upon the ground on the plate. It is now necessary to run this through the press, and when this is done, the tracing will show on the smoked ground sufficiently to enable the etcher to be guided by these lines. When the lines have been removed with a needle which is sharp, but not with a cutting point as for dry-point, the back and the edges of the plate are thoroughly painted over with diluted asphaltum. This has the same protective quality that the ground has on the surface of the plate, with the advantage that it is firmer and can be applied without reheating the plate, which would be impossible at this stage.

Assuming that this brief outline is clear to the reader, let us take a plate, either copper or zinc, and with whiting which has been dampened into a wet paste, cover the plate. As soon as the whiting has dried it is necessary to remove it entirely, for it would cause trouble if some of it got on the ground. The whiting removes all traces on the plate of finger prints or any other invisible marks. Now that the plate is perfectly clean we adjust the hand vise to a corner. The plate should be protected from the pressure of the vise by a piece of paper or a blotter, for any scratch will show in the printing. We are now ready to ground the plate, preferably on an electric heater, or by gas, over a gas plate. The hand vise fulfils two purposes. It makes the handling of the plate possible without touching it, and its wooden handle makes it possible to handle the plate when it is warm. The heating of the plate must be done with a great deal of care, for it must be heated evenly in order that the ground can be applied satisfactorily. As mentioned in the outline the plate must be warm enough to melt the ground when it is applied and still not so warm that the ground will dry by the heat.

While it is possible to make one's own ground I do not advise this, for even the most ordinary ground that can be purchased is better than a beginner can make himself. Ground comes in both liquid and solid form. The liquid ground is poured over the plate by holding the plate at an angle and pouring the ground from the top edge. This is not difficult to do, although one cannot hope for perfection at once, and considerable ground can be wasted before one becomes proficient in doing this. The solid ground comes in the form of a dabber wrapped in silk. The reason for this is that any impurities are kept in by the silk, and the handling of it is made easier by the possible grip on the silk. The warm plate is lightly dabbed, and enough ground is left on it so that when the dabber or roller is worked on it, it will cover the plate. This dabber which is used for distributing the ground over the plate can be bought, or made by stuffing some soft silk with cotton. A piece of kid leather also makes a very good dabber. I personally prefer the roller made of hard rubber.

It is important that one does not use the same dabber or roller for this kind of etching that one has used for the soft ground etching, because the two grounds must not be mingled. When the ground is very evenly distributed on the plate we are ready to smoke the plate. An excellent way of doing this is to cut an ordinary candle into three pieces, place them in a triangle on a saucer, and hold the plate ground downward over the three flames. Once the plate is smoked we again heat it slightly so that the smoke will be absorbed by the ground, making a rich black surface on which to work.

The plate is now ready to be drawn on directly or to receive a tracing of a previous drawing on it. If we work directly on the plate, any fault or tentative lines can be stopped out with asphaltum or shellac before the etching takes place. At this stage a false line on the plate can be more easily corrected than a pen line on a drawing.

Unlike pen and ink drawing the variety of line is not obtained by the pressure of the needle, but by using either light or heavy needles or by the length of time

The printing of an Etching, showing the Etching press

the plate is left in the acid. Sufficient pressure should be applied to the needle to cut through this ground, for otherwise uneven biting will be the result. A drawing that is made directly on the plate without a tracing will probably have more life and vigor, and the charm and spontaneity which are not present in a traced drawing. On the other hand, more careful work can be accomplished by working over a tracing.

We can now apply the acid solution in several ways. Either with a feather, applying the acid first where the darkest lines are desired, and last where the lines are to be very lightly bitten, or by forming a ridge or wall of bees-wax which is put around the edge of the plate forming its own tray, into which the acid is poured. This is especially useful when working on a very large plate. Another, more usual method, is to paint the back of the plate with asphaltum or liquid shellac and place the plate on a tray, pouring the solution over the plate. This solution varies depending upon the type of line, but roughly one part acid and two parts water for copper, and one part acid and six parts water for zinc, are about the amounts used. Since this is only an approximate quantity, the solution can either be mixed first or the water can be poured over the plate and the acid added. When the acid is applied to the plate with a feather, it is often advisable to first apply a solution of one part perchloride of iron and one part water to the plate in order that the nitric acid will bite more easily. The perchloride is left on the plate for a few minutes and then washed off with water before the solution of nitric acid and water is applied. Perchloride solution alone is an excellent mordant which is used extensively in photo-engraving, but the sediment which it forms on the plate is very disturbing, and the fact that one does not see the action of the solution as with nitric acid, makes the solution less attractive to the artist. The variety of line may be regulated by removing the plate from the bath, washing it in running water, stopping out the lines that have been sufficiently bitten with asphaltum or shellac, and replacing the plate in the bath. This is done as often as it is necessary in order to obtain the variety of line one desires. When the bordering wax is used on the plate, it is necessary to pour out the acid, wash the plate, and proceed to stop out the lines.

The next step is to remove the ground and prepare ourselves for the printing. The ground is removed with turpentine or gasolene or any solvent. We are now ready to ink the plate. This is done by heating the plate again and applying the ink either with a roller or a very solid leather dabber. The ink must well penetrate all the lines. We now take some tarlatan and wipe the surface of the plate clean. A print from this plate will lack the warmth of a print where the plate has been manipulated in the wiping. That is to say, by leaving a certain amount of ink on the plate

a tone is produced which adds color and warmth to the print. This is not always considered ethical, but we should be primarily concerned with artistic results.

Assuming that the press is ready for the plate, we place the plate on the bed (base) of the press. We now turn to the paper, which should be soaked for several hours in water, the amount of time depending on the type of paper. The paper is placed between blotters and all surplus water is removed. Then it is placed over the plate and the blankets over it. This is run through the press with the result that we have the first trial print. For this first proof it is desirable to have had the plate wiped very clean, for it is easier to judge the lines without a tone. We are now better able to judge what we have done so far, and to develop the plate further by both burnishing and rebiting. On examining this first proof carefully we find that parts of the plate have probably been over-bitten, while other parts have not taken sufficiently. Where the reduction is very slight, burnishing alone will do, but where the lines are deep it may be necessary to use a scraper before using the burnisher. The scraper is a knife with a three-edged blade, which is used to remove the surface of the plate so that the depth of the line will be correspondingly reduced. We proceed very gradually, and once the lines are reduced to the desired depth, the burnisher or charcoal will need to be used in order to remove the scratches caused by the scraper. The charcoal should be rubbed on the plate with oil or water and then washed off. Do not use ordinary drawing charcoal for this purpose; engravers' charcoal must be used. We may now proceed in the opposite direction, and intensify under-bitten lines or introduce new ones. The transparent re-etching ground which we use now is ordinary ground without asphaltum, permitting us to see what we have already done. There are other methods of taking care of under-bitten lines, but this is the usual and easiest method. While there are liquid grounds which can be applied on the cold plate, I prefer this method, although it means a repetition of the procedure used before in applying ground. The ground applied, we go over under-bitten lines with the needle, and introduce any necessary new lines. After further biting, we again ink the plate and pull another proof. This procedure is repeated indefinitely, until the etcher arrives at the desired result. Dry-point is often introduced at this stage to add to or improve the appearance of the line.

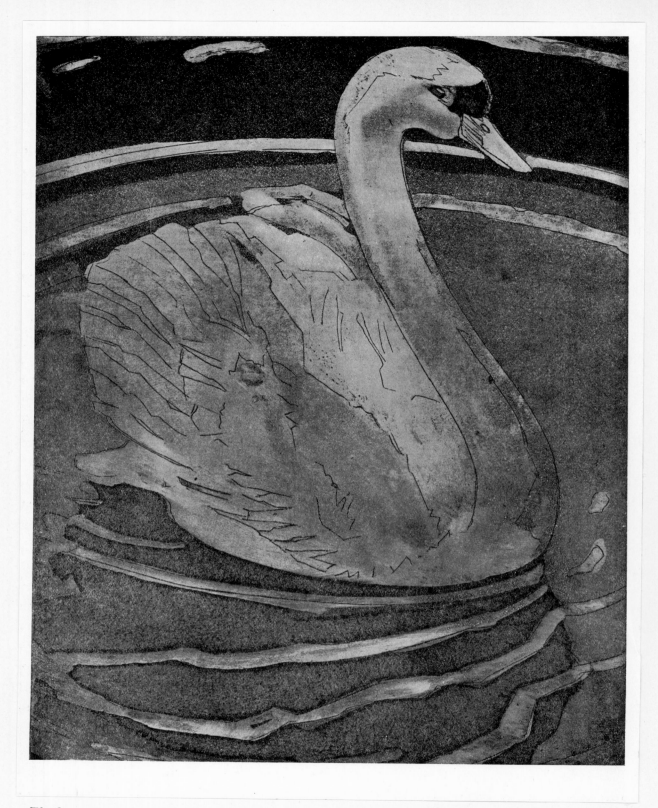

The Swan Aquatint

AQUATINTS

AQUATINT is etching for tone instead of line. This is possible by applying a ground which only partially protects the surface of the plate from the action of the acid. This ground which is first dusted on the plate, and then made to adhere to it by heating, only protects the surface of the plate where the particles of dust have settled. The dust, being very fine, makes the division between the grains of dust so minute as to be practically invisible to the naked eye. It is these uncovered minute grooves which remain exposed to the action of the acid.

Generally the ground for aquatints is first dusted to the plate with a dust box. Dust boxes are contrivances which stir the dust (usually resin powder) and then allow this dust to settle evenly on the surface of the plate. Some of these boxes have a fan within them, which is operated by a lever on the outside, others rotate on an axis. These are quite expensive and cumbersome, and are not absolutely necessary. A way of preparing the plate without the use of a dust box, is to take a small quantity of finely powdered resin, putting it in one or more layers of cloth, depending on how fine the dust is desired, and then from a distance of a few feet (the plate can be placed on the floor, face up) the dust can be applied. The result of applying dust in this manner may not always be the same as with a box; however, this very imperfection will make our print less mechanical.

After the dust has settled on the plate, the plate is slightly heated over a gas or electric heater, thus causing it to adhere to the plate, care being taken not to overheat it, for this would make the grains of resin dust melt and spread to the extent that the plate would become so fully protected that the acid would not affect it.

Resin dust can be applied on a plate on which an etching has been made, or, better still, on a plate which has been etched on a soft ground. The lines on soft ground plates are more related to aquatint than the etched lines, and the two can be well combined. Assuming that one is working over an etched plate, after the dust has been applied and later fixed to the plate by heat, the next step is to protect the back of it with asphaltum or shellac. After this has dried, the plate is turned over to the side where the etching is, and which can be clearly seen through the ground. We begin by stopping the parts on the plate we wish to retain pure white. The plate is now immersed in the acid bath (the strength of the nitric acid, as in regular etching, is based on whether we are working on copper or zinc), and the plate is left until the lightest gray has been bitten. The plate is now removed from the acid, washed, dried in blotters, and the area which is to be left light gray is stopped out (as in etching, with either asphaltum varnish diluted in chloroform, or with diluted shellac). After this stopping-out process, the plate is again put into the acid, and it

is left until the next deeper value has registered. We again repeat what was necessary to do for the first value, and continue the stopping out and etching until we have all the tones we seek, and the plate stopped out except for the last and deepest value. When this stage is reached, the next step is to remove the resin ground and the asphaltum or shellac from the back of the plate with a solvent. After this the printing takes place as in regular etching.

The result of any direct process is always less certain than the mechanical, such as photo-engraving, etc. Again, knowledge without experience is not sufficient. Therefore, unless one constantly applies himself to one process, aids are necessary. In etching, which includes aquatint, it is advisable to first treat a small trial plate in the identical manner as a finished plate, and give the trial plate as many etchings in the same solution and for the same duration of time as the finished plate will be exposed to. To do this takes additional time, but no surer way can be advised to protect one from disappointments. Aquatints not worked over an etched plate are simpler, because the first etching process is eliminated. In this case, after the resin dust has been fixed to the plate, we trace or draw on the grounded surface. The drawing or tracing represents our boundary lines of values, consequently our drawing must be of patterns.

Litho tint effects are imitated by aquatint in this manner. On a resin ground plate, the ground being either over an etched plate, or on a drawing made on the resin ground, diluted nitric acid is applied with a brush. In this case the etching is done first for the darks and followed by the lights. The reason for this is that no stopping-outs are employed, nor is the plate given an acid bath. Instead, the acid is applied as a water color wash, and since the diluted acid that is applied to the plate first etches longest, where this is applied the value will be deepest. The separation of values in this type of etching can be less definite. In fact, the blending of one value to the next can be very subtly done, so much so that the effect will not be unlike a lithograph print made with a diluted black substance, known as "Touche," as used for making "Lithotints."

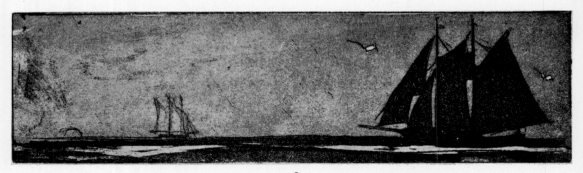

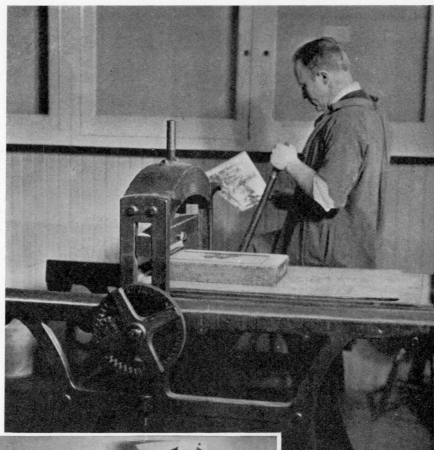

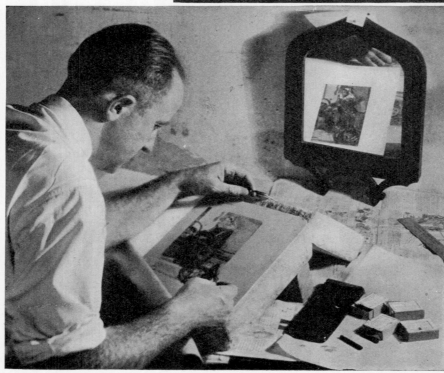

Showing the litho-
graphic press and
the Author work-
ing on the stone.

Lithographic Terms.
A Lithographer, the artist
who draws for lithography.
A lithographic printer, one
who prints for the artist.

LITHOGRAPHY

LITHOGRAPHY is by no means a new medium, it having been invented by Aloys Senefelder in 1776. This is a flat surface process which occupies the intermediate position between relief and intaglio printing.

While the knowledge of lithographic printing indirectly helps the draughtsman, this need not come until later. To begin with all one needs to know is that lithography or planography (when not drawn on stone) in its simplest terms is nothing but the drawing with a greased substance on a grained surface, which, when chemically treated, will cause the ink from the roller to adhere to the drawn lines while the undrawn part of the stone or plate, which is kept moist with water, rejects the ink and remains clear.

For a number of reasons lithography appeals to the artist. One of these reasons is that a fine expressive line and a clear rich black can be obtained; another, that there is no mechanical screen as in photo-engraving which, however invisible, takes the clearness and delicacy away, and again because many originals can be produced in place of one drawing.

Briefly, the process is this. When the design has been transferred or drawn on the plate or stone, the plate or stone is treated with a solution of gum arabic and with etch, both of which act as a protection to the undrawn surface against the ink of the roller when the printing takes place. At no time during the procedure is anything done to fix the drawing to the plate or stone—everything is done to keep the ink from adhering to the undrawn surface. It is the undrawn part that is fixed, not the drawing. After the surface has been treated with gum arabic and etch, it is ready for printing. The etch is washed off, the surplus gum solution is removed, and the surface of the crayon—the black of it—is removed with turpentine. While the plate is still damp, the roller is passed over it—inking the drawn greasy lines only. A dampened paper is now placed over the plate, both are run through the press, the scraper of which presses the paper firmly against the plate, and a print known as a lithograph results.

To those who do not intend to do their own printing, something which a beginner should not attempt, drawing for lithography will not be difficult, assuming that the prospective lithographer can draw. To take advantage of all that lithography offers, the drawing should be made directly on the stone. However, there are other ways of making so-called lithographs, ways that, because of their greater convenience, are used by well-known artists.

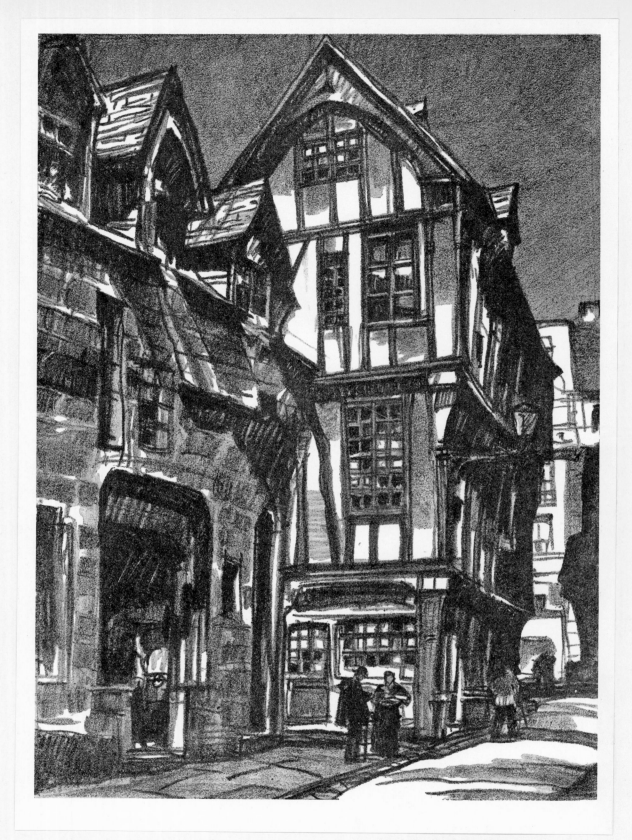

Rue St. Romain, Rouen, France A Paper Transfer Lithograph

62

LITHOGRAPHY FROM PAPER

A DRAWING made with a lithographic crayon on any kind of paper can be transferred to the stone or plate and a lithograph made from it. While lithographs made in this manner do not have the crispness and life that a lithograph that has been drawn directly on the zinc or stone has, the advantage of using paper is obvious. Paper is inexpensive, it is light in color and weight. It is something with which one is already familiar. It is ideal for outdoor and spontaneous sketching, and finally, a drawing made with lithographic crayon on paper need not be made in reverse to obtain a positive lithograph. The lithograph on p. 62 was made on zinc from a paper transfer. This drawing was made on tracing paper that comes on what is commonly known as art directors pad.

Drawings made in this manner need to be transferred to the metal plates as soon as possible after they are drawn, the reason for this being, that while the crayons themselves do not noticeably dry up with age, the greased substance of the crayon when it is applied to the paper becomes absorbed and dries in the paper, and since it is this greasy substance which we are aiming at transferring to the plate or stone, and not the carbon of the crayon which has no value except to indicate where we have drawn, we must transfer as soon as possible. This is particularly true when drawings are made on papers not intended for transferring. The papers intended for transferring are so prepared that the litho crayon with which one draws is not so readily absorbed by the paper. In Paris, Rancon on Rue de Seguir will prepare the surface of any favorite paper for 50 centimes a sheet, thereby facilitating the transfer.

The transferring of the drawing to the plate or stone is done in this manner: the drawing to be transferred is first dampened between damp blotters. The length of time it is left to dampen is based on the kind of paper on which it was drawn, the period of time since it was drawn, and the grade of litho crayon used. The older the drawing to be transferred, the longer the time required for the dampening, but no amount of dampening will help a very old and dried-up drawing.

After the drawing has been sufficiently dampened, it is placed face-down on a litho stone or metal plate, one inch or more larger on the four sides than the drawing, to allow the scraper of the press to come within the metal plate, run through the press for a number of times, and when the dampened drawing is removed most of the crayon will be left on the metal or stone.

Coarse Sand Paper

Canvas

Coarse Canvas

The drawing which is now on the plate is fanned until all the water absorbed by the crayon has evaporated. The plate or stone will then require more than usual care in treatment, because that which has been left on the surface has not the firm grip as when a direct drawing takes place. As always, the half-tones are most affected, and for this reason a drawing to be transferred should be more vigorous and more definite in value than when one draws directly. This, and the fact that the work becomes neutralized to a degree, give lithographs made from transfers less subtlety than lithographs drawn on the stone or plate.

For a successful transfer, the stone must be absolutely flat, or when transferring to metal plates, they must be placed over a flat surface (which is usually a litho stone). The scraper must be in particularly good shape, and the backing must be very even.

Although the process of transferring from paper to stone or plate is identical to printing, more backing than when making a print is preferable. This is accomplished by adding blotters between the drawing to be transferred and the plate paper which comes in contact with the scraper. Having padded the backing with extra blotters, unusual pressure is not necessary, but evenness and ease of operation are, and the press should be running smoothly. This can be helped by lubrication.

Varieties of textures are possible by placing different surfaces under paper on which a drawing for a lithographic transfer is made.

Papers ready prepared for transferring are not favored by artists, for while better transfers may be possible by using such papers, their surfaces are so unsympathetic as to discourage any artist from working on them, and artists are more interested in the artistic than in the technical results.

Working in this method is the easiest for the drawing, but the hardest for the printing, and since drawings made to be transferred can be so easily mailed to a professional printer, this can always be a solution when printing is either difficult or impractical.

The advantage of drawing on a white surface such as paper, which is not expensive and can easily be replaced, and the fact that one can carry it so conveniently, and also because one can indulge in a certain amount of scraping to create unusual effects—something not possible to do on the metal plate—all tend to make paper a good medium for the beginner. Furthermore, drawings made in lithographic pencil when one does not desire to convert them into lithographs, are very attractive in themselves, for a litho pencil and crayon possess a very distinctive richness.

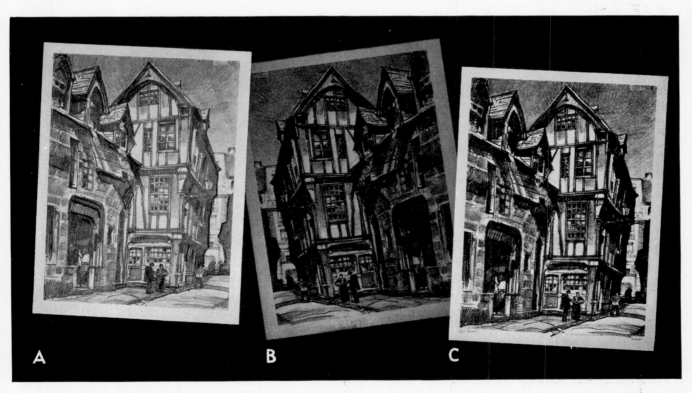

Transferred from paper: (A) Original drawing after being transferred. The drawing is now much lighter, the black grease having been transferred to a zinc plate. The dark outlines were made with a softer crayon which transfers more grease and lends emphasis. (B) Zinc plate inked and ready for printing. (C) The finished lithograph.

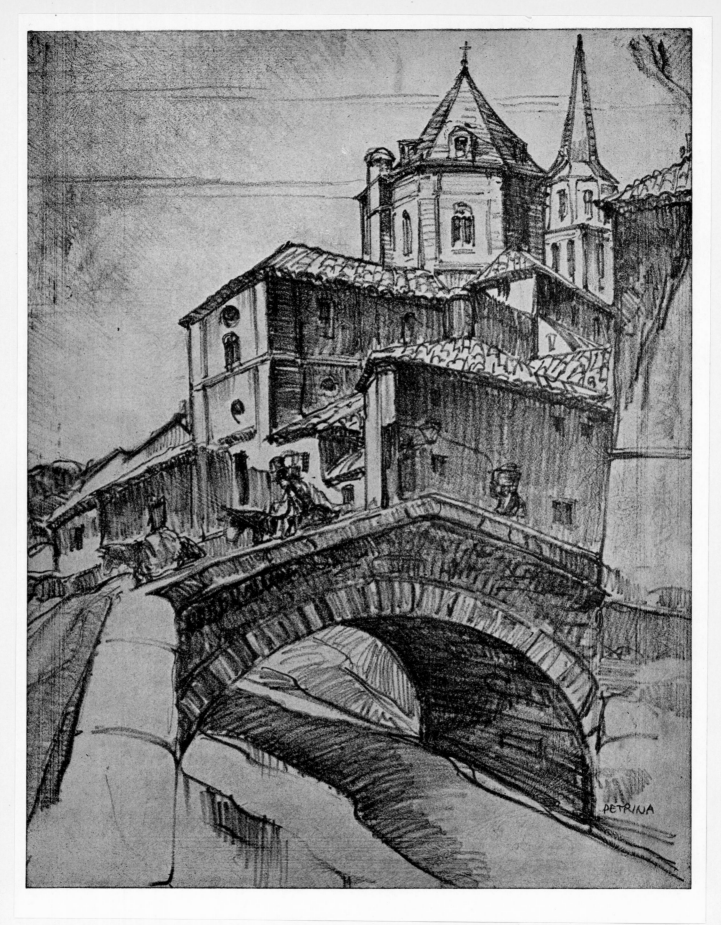

Granada, Spain

A Metal Plate Lithograph

66

LITHOGRAPHY FROM METAL

WHILE there is really no substitute for the Kelheim Stone as a substance and surface for lithography, its weight and bulk make it at times difficult if not prohibitive to use. By graining zinc and aluminium plates, a surface similar to the stone is produced. This surface is needed for two reasons. One, that it will retain water, and another that it will prevent the roller from sliding in the inking. This grained metal surface will hold gum (which in turn absorbs water) so firmly that even constant dampening does not remove it. It is the water which is applied while printing and is retained by the film of gum that repels the ink from the metal. The metal plates are grained by being fastened to the bottom of a grainer, which is really a tray, fully covered with marbles. Graining material which consists of fine flint or pumice powder produces the graining when the grainer or tray is in motion. Water is added from time to time to clear out the mud formed and to assist the rotation of the marbles. Plates used for fine, or transfer, work are grained for about a half-hour with steel clay marbles and fine flint or pumice powder.

Because zinc and aluminium plates oxidize very readily, and more so after the graining has taken place, plain zinc and aluminium plates are kept in stock to be grained as they are ordered. Even so, before proceeding with drawing on a zinc or aluminium plate it is safer to apply a counter-etch solution which will remove any oxidization which may have formed. This counter-etch solution usually consists of two or three parts of hydrochloric acid to a hundred parts of water, or 32 oz. of water, $\frac{1}{4}$ oz. nitric acid, and a handful of alum. This is applied to the plate for about five minutes and then the plate is thoroughly washed and quickly dried, for delay in drying will affect and ruin the surface.

Having prepared the metal plate, our next step is to transfer to it the drawing which we wish to convert into a lithograph, and which should be at least one inch smaller on the four sides than the plate, to allow the scraper to come within the edges. When a drawing has been made with anything but a lithographic crayon or pencil, it is first necessary to make a tracing of it, transfer this tracing to the plate, and then redraw it, this time with a lithographic crayon or pencil. The tracing is done in the usual manner; that is, a sheet of thin but not too smooth tracing paper is placed over the drawing, and the main lines traced. In this case the traced lines must be made with a non-greased pencil or crayon, and they should not be in black, for if they are, this will confuse one later, when the lithographic crayon, which is

Reproduction of Zinc Plate from which lithograph on the opposite page was printed. Attention is called to the deep blue gray color of the plate.

Château Frontenac, Quebec, Canada A Metal Plate Lithograph

Lithograph from the metal plate shown on opposite page. This drawing was made with the side of the crayon. Illustration, page 66, was also made on a Zinc Plate, using the point of the crayon. This was printed by the artist on an etching press.

69

also black, is used. For tracing, a contè sanguine crayon or pencil is excellent, it being non-greased, none of the lines drawn with it will show on the final print, and being reddish in color, its lines can at once be distinguished when the drawing is made with the lithographic crayon. As little tracing as possible should be done. If the tracing is too complete on the plate or stone, it will have a tendency to make the lithographic drawing seem more finished than it really is, and because of th prints taken from it may appear incomplete. The tracing is placed over the plate with the drawn side facing it, and the back of the tracing is then rubbed with the thumbnail until the transfer has taken place. This transfer will be in reverse, as it should be, for we are now working on the stone or plate, which is really a negative, and only by drawing on this negative in reverse can the print (positive) be like the original drawing.

Drawing on a metal plate differs very little from drawing on stone, except that we are handicapped by its color, particularly in zinc, which is a bluish gray, and consequently we are apt to misjudge our values, for a dark line does not seem as dark in value on a metal plate as it will when the printing takes place on a light tone or white paper. Another unattractive feature of zinc is that we cannot remove the drawing by scraping, as we can when working on stone. The nearest approach to the effect produced by scraping is by treating the plate, before the drawing with the litho crayon takes place, with a solution of gum arabic where pure whites are desired. Very fine white lines, such as are possible when scraping on the stone, can be produced with a small brush and diluted gum arabic. Scraping on the metal plate will only produce the opposite result intended, because one would only remove the grain which is necessary to repel the ink, and having removed this grain the ink will adhere and give black instead of the white which the scraping does on stone.

When the drawing on the plate is finished, the procedure toward preparing it for the printing differs very little from the method used on stone. First, a gum arabic solution is applied, then the carbon of the crayon is removed with turpentine, then the plate is "rolled up" with litho ink to the intensity that the litho is desired. Next, talcum or resin is dusted over the ink, and finally the etch is applied. Because a metal plate is not absorbent, the etch need be left on the plate but a short time, and not for hours, as when the stone is treated. The etch for metal plates is a solution of gum arabic and chromic acid, and for aluminum plates it is gum arabic and phosphoric acid. Should the plate show a tendency to scum, a second etching will usually clear it.

The paper to be used in lithography should be dampened and, generally speaking, must be soft and at the same time firm. For the artist, another great advantage the

metal plate has in making lithographs is that a metal litho plate can be printed on an etching press, in very much the same manner as an etching—which is something one cannot do with a stone. Since etching presses are more numerous and more accessible than lithographic presses, the printing of a metal plate lithograph is within the possibility of almost anyone.

When using the etching press for printing, less pressure is needed than when making an etching, as in this case the paper does not need to penetrate the lines which in lithography are on the surface. The pressure used in making an etching would flatten the grained surface of the litho plate and injure it.

When printing in this manner, after the plate has been inked it is placed on the bed or base of the press, face up, the dampened paper is now placed over it, and finally, instead of a wool blanket as in etching, a rubber blanket is placed on the paper and the whole is run through the press. If a rubber blanket (such as used for offset printing) is not easily obtainable, blotters or soft cardboards can be used as substitutes.

To summarize, metal plates have these advantages over stone: They are comparatively inexpensive, they are very light in weight, because they do not take up room they can be easily stored, the printing can take place as new prints are wanted, and last but not least, they can be printed on either a litho or etching press. Besides, because of their lightness they can be mailed to a professional printer, who, because of his experience gained by constant printing, can undoubtedly produce better results in the printing than a beginner can hope for.

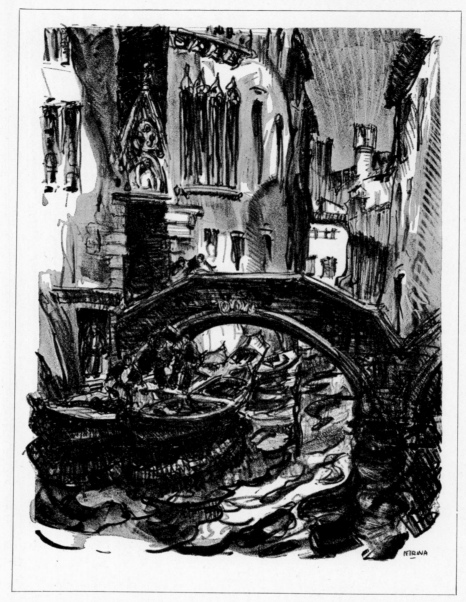

Bridge of Paradise, Venice A Lithograph from Stone

This reproduction of a print from the stone shows why
stone, in spite of its weight, is the preferred surface for
lithography. Scrapings in the shadow of the building on
the right, and on the sky, could not have been possible on
a metal plate. The surface of the stone gives the drawing
a texture comparable with painting. This print was pulled
for the artist by Desjobert, Paris.

LITHOGRAPHY FROM STONE

THE Kelheim Stone on which one draws to make a lithograph is a stone that in its natural state absorbs both water and grease. This stone is named after the little city in Bavaria near where deposits of these stones are located. This Kelheim Stone is a natural product and consists of 97 per cent of carbonate of chalk. Geology explains that this formation reverts to the Coal Period when the Jura Mountains were below the surface of the sea. When the waters receded, deposits of lime containing marine life were exposed, and in time this petrified, so that fossilized fish are sometimes found embeded in the stone. The stone is usually located some 60 ft. from the surface in strata of about 30 ft. deep, and the layers are from $\frac{1}{32}$ in. to 12 in. thick.

The average thickness of the stones when intended for lithography is about 3 in. to 4 in. Frequently, two layers are joined to give it this height, which is needed to strengthen the stone so that it will resist the pressure of the press. Small stones can be quite thin, while larger ones need to be correspondingly thicker.

Generally speaking, the stones come in two grades. The better grade is suited for artistic lithography, is good for either crayon or for "Touche," and is of a very light blue-gray color. It is quite hard, and takes a very fine texture. The other grade, which has a yellowish tint, is softer and coarser—this kind can only be used for crayon work. No two stones are identical, and none are perfect. However, and particularly in smaller stones, it is not difficult to find stones that are near perfect.

Drawing on stone, unless intended for very large editions, a rule in commercial work but an exception in artistic lithography, need not be done very differently than if one were to draw on most any other surface. When one does not do his own printing, a good litho printer can print from almost any drawing. In fact, there are printers who enjoy breaking the monotony of their work by printing drawings which have been unusually handled. Drawing from the object to the stone has been, and is being, done. While this may help to make the work when successful more spontaneous, the artist who becomes interested in lithography should demand more of his work than just that. This being the case, as much or more spontaneity of touch is obtained when one works from a drawing which has been planned out, and is to the satisfaction of the artist.

Drawing directly from the object or model to the stone has the disadvantage, that since it is impossible to draw from the model or object to the stone in reverse,

the drawing will be in reverse when the printing takes place. Everything considered, it is better to first make a finished drawing on paper either with a litho crayon, or when corrections are anticipated, with something more flexible, such as a carbon pencil. Carbon pencil erases, while litho crayon will not. Having made the drawing, which again should be fully one inch on the four sides smaller than the stone, the tracing which we need to transfer to the stone is not done differently than when transferring for any other purpose—except that the medium we use to transfer with must not contain the remotest trace of grease or graphite. If it contains grease, these traces will show in the printing, and if it contains graphite (such as lead pencil marks), the graphite will prevent the litho crayon by which the drawing is finally made from attaching itself to the surface.

A good way to get a tracing to the stone is to first place a thin transparent paper over the drawing, trace the essential lines with ink, rub these lines over with a contè sanguine crayon, lay this tracing face-down on the stone and glue the margin to it, so that it will not slip, then with a hard point (H pencil) trace over the ink lines, which will show through the tracing paper in reverse. When finished, remove the tracing paper and proceed with the litho crayon.

Litho crayons, not being dry and firm like ordinary crayons, need to be handled with more care. The hardest crayon #5 (copal) has much less grease in it than the softer grades. For this reason, while a firmer point is possible with this crayon, less grease substance to resist the action from the gum and etch is left by it on the stone. The softer crayons, on the other hand, have a tendency to completely fill the grain of the stone, thus producing a solid but not luminous black. The strength of the etch, applied after the drawing is completed, is based on the degree of resistance of the crayon used. This is the reason why it is not practical to use both very hard and very soft crayons on the same drawing. Drawings made with a hard crayon require a weaker etch than when made with a softer one.

The etching of the stone will be more successful if hard and medium, or medium and soft, crayons are used—and preferably if a one and a two, or a two and a three, etc., are used instead of skipping numbers.

"Touche" is used for making litho tints. In this case the grease which will attract the ink in the printing is applied in liquid form instead of with crayon. This is definitely a less certain manner of working—because the water by which "Touche" is dissolved dampens the stone when the "Touche" is applied, so that the effect at this time is much darker than it will be in the actual print. Scraping the stone to introduce white lines or to eliminate parts that are not wanted should be reserved to the last, for the surface of the stone is naturally affected when this takes place, and

parts that are redrawn over a scraped surface will show. Elimination is easy, but corrections are difficult.

Having completed the drawing on the stone, the preparation for the printing follows. The method varies with different litho printers. One method is to apply very thinly to the surface of the stone gum arabic dissolved in water to the consistency of cream. This fixes the undrawn parts and only the drawing, which, having been made with a greased substance (the litho crayon), remains exposed. The carbon of the crayon is now removed with a solvent such as turpentine. Ink is applied with the leather litho roller until the drawing which disappeared when the carbon (the black) of the crayon was removed, not only reappears, but this time shows as rich as the prints are desired. At this stage but a few prints can be made, before the stone will go black on us, therefore more gum solution, this time with nitric acid added, is applied. This constitutes the etch, the purpose of which is not to affect the surface of the stone in any way, but to make the gum solution more receptive and more penetrating to the stone. This second solution known as the etch is left on the stone, not for a few minutes as in the metal plates, but preferably hours, and, when possible, overnight. If only a few prints are required, the time the etch is left on the stone can be considerably shortened.

Since lithography offers advantages of texture that can be compared with painting, one should utilize these, and work for the variations which give tone and quality. Lithography has an advantage over etching in that one can clearly see what the drawing will be like, providing, of course, the stone is not hurt before chemical treatment takes place.

While methods of producing lithographs can be described, there are no definite rules for technique. The work of the masters Gavarni, Daumier, and Goya and others will show how personal and varied technique can and should be. Technique should reflect the artist and, since artists are individuals, each one's work should be as personal and as different as he is himself.

To me, lithography is the art of the day, for when the printing is done for the artist, he is left to concentrate fully on his own expression, obtaining results with greater freedom and rapidity than is possible by any other method of artistic reproduction.

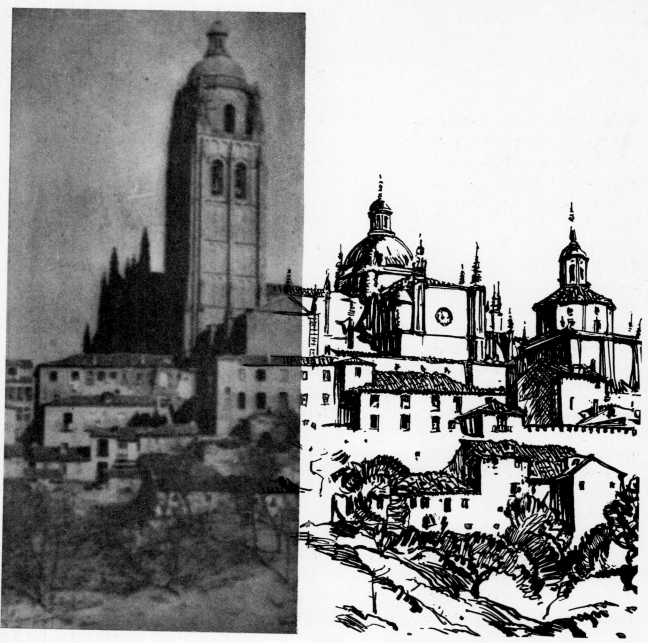

Unbleached portion of photo
Half-tone reproduction

Bleached photo
Line reproduction

This example shows how the photograph appeared before it was bleached. Note how the photograph itself was not sharp—this is desirable for working over purposes—for a sharp photograph would not show the inked lines as clearly as a faded print does. A little retouching was made on the drawing after the bleaching took place. Photo bleaching is particularly helpful in rendering mechanical or other accurate subjects.

PHOTO BLEACHING

WHEN photographic accuracy but not photography itself is preferred, a photograph can be used as a basis for pen and ink or crayon rendering. By later bleaching the photograph only the pen or crayon work will remain, while the photograph itself will totally disappear.

The photograph, which should be a silver print, should not be too strong or too contrasting, for if we work over a strong photograph what we do will not be clear.

For mechanical and architectural or any inanimate subject, where a faithful and photographic presentation is required, this manner of preparing copy for reproduction is a great time saver. It is advisable not to complete the drawing over the photograph until after the bleaching. By drawing the main lines and essentials first, and then bleaching the photograph, the final treatment can be done with greater freedom than when the photograph is visible.

When the drawing is made the photograph must be bleached out. To do this, submerge the drawn-over photograph with a liquid bleach. The rendering must be produced in a medium which will neither wash off nor be affected by the action of the chemicals. Lithographic crayon is therefore good, because it contains grease, and so is waterproof India ink which, as the term implies, is insoluble in water.

Bleaching solutions can be obtained from photographic supply stores or can be prepared by the chemist. Some permanently bleach the photograph, while others make it possible to bring back the photographic image by later applying a weak solution of ammonia. Cyanide of potassium, bichloride of mercury, and other chemicals are used to bleach photographs. When ferro-cyanide of potassium is used, a little iodine must be added to prevent the print from later turning yellow.

Artists working for reproduction should not be prejudiced against working over photographs, when by so doing the result will be more satisfactory. While it would be difficult to produce an inspired drawing in this manner, it would be equally difficult to produce a drawing of photographic accuracy by any other means.

Photo-bleaching is generally used when a line-cut is preferred to a half-tone reproduction, either because it is uncertain on what kind of paper the cut will be printed, or because one definitely knows beforehand that a half-tone is impossible. Apart from the fact that it is safer to print from line engravings, line reproductions are more closely related to type faces, and more unity of feeling is achieved on a printed page with line engravings than with half-tones, which would be necessary in the reproduction of a photograph.

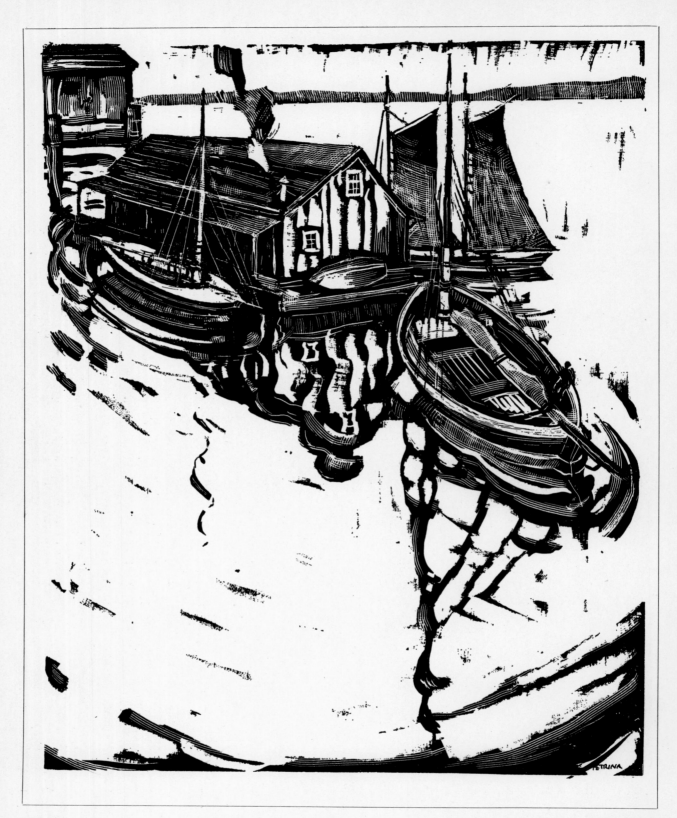

"Reflections"

Chalk Board Drawing

78

IMITATION WOOD-ENGRAVING

THE revival in the interest of the wood-cut has brought to the front means of producing a very close imitation, without the labor necessary in producing a real wood-cut or wood-engraving. Wood-cuts and wood-engravings are not as practical today as they were in the day of hand printing presses. The great pressure to which they are put by the modern presses makes them short-lived. Therefore, when a large edition is needed, electros (see under "Reproductions") are made from them, and the printing is made from the metal cuts. Since this is usually necessary anyway, the drawing in many instances can just as well be made on a chalk surface board which can more easily be scraped and more readily corrected than a wood block.

Chalk board is a board which has been treated with a thin coating of chalk. The usual procedure is to cover the board evenly with India ink. When the drawing is small, waterproof India ink can be used, but on large surfaces ordinary India ink is preferable, as it is not so likely to crack as the harder and more brittle waterproof ink. Having turned this white board into a solid and even black surface, the drawing is traced or made directly on it with a blue pencil. Blue does not reproduce, therefore these blue lines will not be seen when the drawing appears in print, but they will serve towards directing one in the scraping out of the whites. A very sharp penknife can be used, or the tools of a wood-engraver can be applied if one desires to imitate the wood-engraver's technique. The large areas of white should be scraped off first and the detail can follow. One of the great advantages of scratch board is that if one does not scrape too deeply into it, corrections can be easily made by just re-inking the false lines and re-scraping over them if necessary. The very fine lines can be produced with a needle as in etching, but when this is done, one should know beforehand the size that this drawing will be when reproduced, for if too great a reduction is made in the reproduction, these fine white lines on black will be further reduced in width, and consequently they will fill in and cause a solid black.

When less detail is required than is possible on chalk board, a substitute for chalk board can be produced by coating a Bristol or hard surface board with a soft lithographic crayon. The surface must be made uniformly black by rubbing the crayon after it has been applied. The back of a toothbrush or some similar object can be used for this purpose. Once the board is so prepared, place over it the drawing to be made into an imitation wood-engraving, and then trace the main outlines with a

very hard pencil, a dull etching needle, or any instrument which, though sharp, will not cut into the drawing. The back of the drawing when thus gone over will totally or partly remove the lithographic crayon, leaving a white guide line to work from on the prepared board. Now we can begin to scrape away the surface of this board. This can be done with an ordinary penknife for the broad lines, and an etching needle for the fine ones. The shavings caused by scraping can be removed with a soft brush. When the drawing is meant for reproduction we must work for a definite white line, for otherwise the results in the reproduction will be uncertain, since in line-cut reproduction there are no grays, and a gray line will print white or be lost, depending on its intensity. Also, we must remember that if the drawing is to be reduced, in the making of the cut, the very thin lines will fill in, and therefore we must make the thinnest line in the original wide enough to stand this reduction.

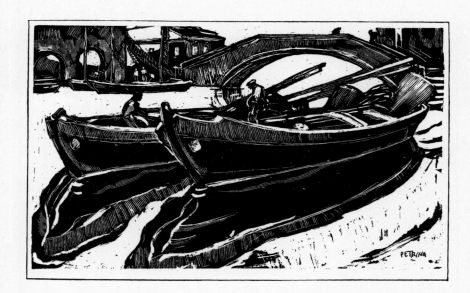

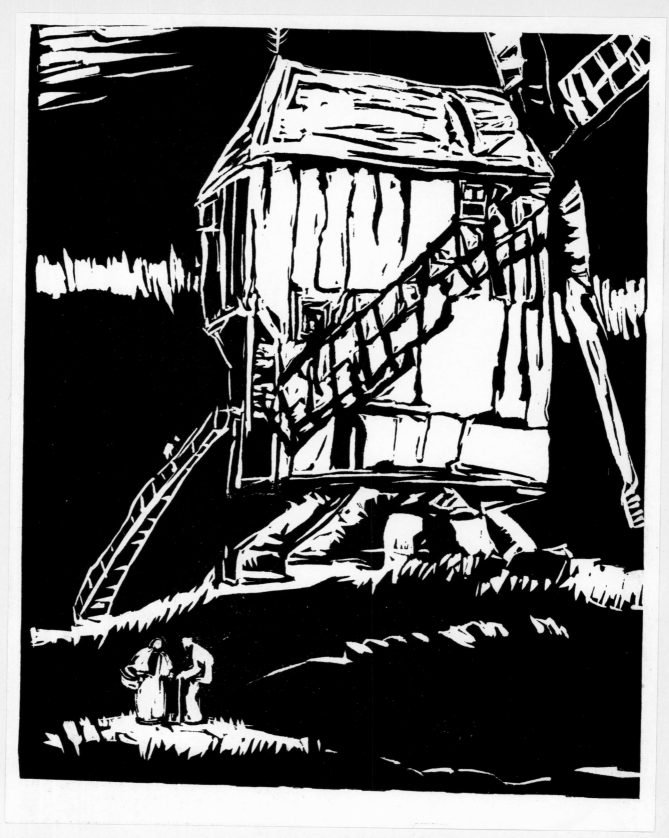

Windmill Printed from an Electrotype made from the block

BLOCK PRINTING

WOOD, linoleum, and hard rubber are three of the substances generally used to make the block for block printing.

Wood, linoleum, or hard rubber cuts are far simpler to make than the complicated wood-engraving, with which they must not be confused.

Block making may be divided into three parts—the drawing, the cutting, and the printing. In making a drawing for the block we must, more than ever, aim for the extreme simplification of pattern that block printing imposes upon us. However, these very limitations can be made to give us something artistic and decorative.

When using wood no preliminary treatment is necessary, for wood-blocks may be purchased all ready prepared. This is likewise true of the hard rubber composition, but for linoleum, it is usually, if not always, necessary to remove the oil from the surface with household ammonia and by sand-papering.

A drawing made directly on the block is preferable, for then nothing is lost in the transfer. Corrections of the drawing are easier to make on the block than on paper, for the block may be readily washed. The only objection, if any, in working this way, is that because we are not working on a white surface, it is not as easy to visualize the result as it is when working in brush on paper. However, this can be offset by first painting lightly over the block with white tempera. The tempera must be applied very thinly, for otherwise it will chip off and prove very disturbing.

Sketch for Block Print (in White on Black)

In preparing a drawing for block printing, neither pencil nor pen and ink is a desirable medium. The sketch should be produced with a medium more closely approaching the cutting of a block, such as the brush. Since neither pencil nor pen can be imitated in block printing, a sketch made with either pencil or pen will not give us the feeling that a block print gives.

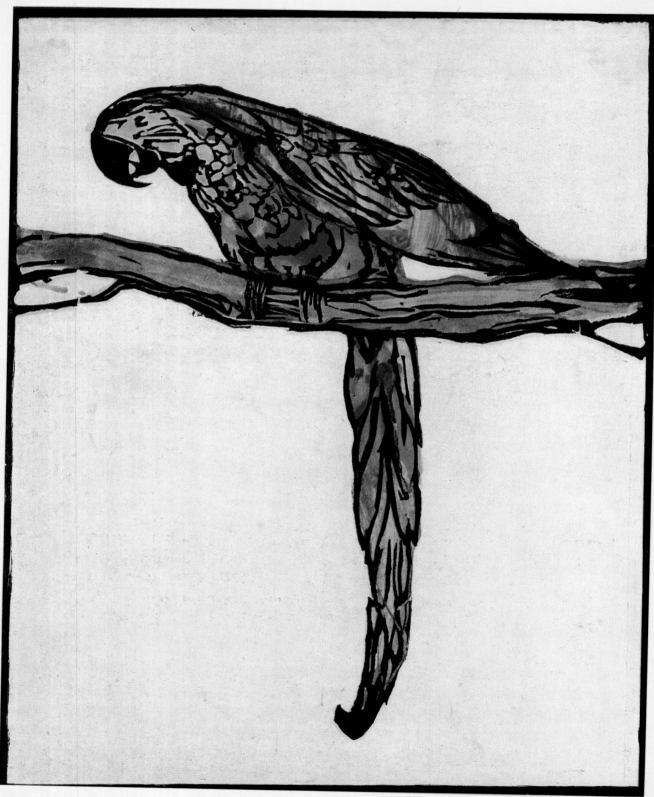

A Parrot

Linoleum Cut

A better method than working with brush on white, is to make the sketch with white on black (see illustration on p. 83). The white tempera will represent the parts that will be cut away on the block, and the edges produced with white on black come nearer to giving us the effect we try for.

Whether one paints directly on the block or works from a brush drawing made on paper, the more sketching and planning done beforehand, the more certain the result. There should be no deciding at the time of cutting. The decisions must take place when the drawing is made. When the artist does not desire to redraw on the block and prefers to work from a drawing which has been either traced, transferred, or pasted to the block, the treatment will be as follows for tracing: The tracing should be made with red ink, so that when we go over the lines with a hard pencil we will know which lines we have traced. This tracing should be placed on the block face-down, and since it has been done on transparent paper, we will see the inked lines through it in reverse, and the print from the block will be like the original.

Having made this tracing of the drawing to be transposed, the tracing is placed over the block (face-down, as explained), a carbon paper is placed under the tracing, and the tracing is gone over with a hard pencil in order that the drawing be traced on it. If the block has been treated with white tempera, a black carbon paper would leave a very pronounced line. If, on the other hand, the block has been treated with black to enable us to see the parts that will print from parts that will not, after the cutting takes place, then a white or a colored carbon paper will show the tracing better.

When the tracing is made on a white block with black carbon paper, it is better to fill in dark areas with a brush, and reduce the drawing from lines to pattern. This is likewise true if we work on a block which has been made black with India ink and the tracing has been made with white or colored carbon paper. In this case the procedure is naturally the reverse—that is, we fill in the white areas with tempera and again reduce the design from lines to masses.

Another method, less frequently used because of the necessity of a press, is to place a piece of transparent semi-absorbent paper over our design, and whether the design has been made with white on black or black on white, we proceed by tracing with a brush and filling in the black patterns with India ink. This tracing is now allowed to dry, and when dry it is placed face-down on the block. A blotter saturated with household ammonia is now placed over it, a few papers placed over this, and the whole is put under more than ordinary pressure of the letter press. Within a few minutes (the time required is based on how long it is since the tracing was made,

BLUE - GREEN COLOR BLOCK.

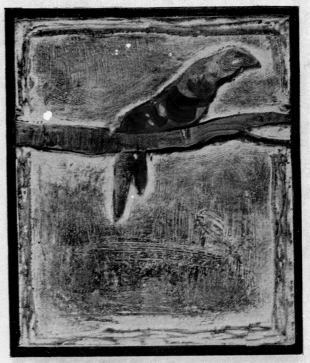

YELLOW - RED COLOR BLOCK.

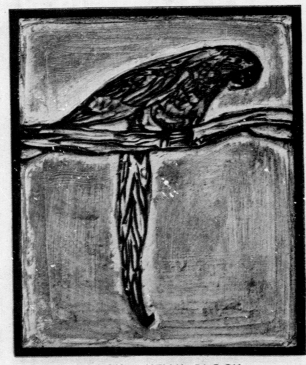

BLACK "KEY" BLOCK.

SHOWING THE BLOCKS NECESSARY TO PRODUCE THE BLOCK PRINT ON PAGE 84.

THE COLOR ON THE COLOR BLOCKS WAS APPLIED WITH A BRUSH. THE BLACK OF THE "KEY" BLOCK WITH THE "BRAYER" OR ROLLER.

the type of paper on which it was made and the surface of the block) the transfer will take place. By lifting a corner of the paper we can see whether or not we are ready to remove this transfer. One cannot hope to have the transfer as sharp and as well defined as the brush drawing from which the transfer is made, for a certain amount of ink remains on the paper. However, when done well, the result will be such as to allow the artist to proceed with the cutting on a drawing which is in reverse on the block, which means that the printing will be like the original.

Yet another method is to make a brush drawing, again on transparent paper, and paste this face-down to the block, allowing it to dry thoroughly before the cutting takes place. In this case, paste is used, not gum or glue. This method, however, is not always satisfactory, for the paper often tears and curls up as the gouge cuts through.

When the design is on the block, the cutting is comparatively easy, though until one acquires proficiency, care must be taken not to lose control of the tools, and not to cut away more than one desires to. One should form the habit of working away from the design, so that if the gravers should slip no harm will be done. As soon as the large areas have been cut, talcum powder or powdered silk finish magnesia can be dusted into the grooves, and this will help to bring out the darks and give the artist some idea of how the print will look. Having cut away the large masses, one should become more cautious than ever, because it is in the fine cutting where the danger lies.

One need not begin with many tools. A sharp penknife, a gouge, a small V and a small U shaped "veiner" are all that one needs to begin with. However, they should be kept well sharpened, either with an oil stone, or with a fine emery paper (double O). When properly done, very little sharpening is required.

When the artist limits himself to one color printing, the process is far simpler and faster than the printing of an etching or lithograph. One color printing represents either printing in black on white or colored paper, or with colored ink on white or colored paper. When colored ink is used on a colored paper, and the print is matted on a white mat, the effect is that of a two-color print, though only one color was used.

A block print in color is more complicated. Not only does a separate block need to be made for each color, but in the printing they must register accurately, and this requires considerable planning.

The steps towards producing a block print in color are similar to those of a one-color print, except that the dark pattern becomes a key plate on which other colors are based. The picture of the parrot in outline is the key plate. From this a print was made, and while the print was still damp it was placed, face-down, upon another block, leaving an imprint, in reverse, on the block which corresponded to

the key plate. From this block was removed all but that which was wanted to print in blue. In this case the blue was placed unevenly intentionally, so that it would range from yellow to blue. This same transferring was repeated, and from the third block all but that which we wanted to print red was removed. The red was also applied unevenly when the printing took place, intentionally. Having prepared the three plates, the black, the red, and the blue, we proceeded by printing one color at a time, ending with the key plate which brought and held the colors together.

The proper registry of these three colors is possible by making "a corner" that will hold each block exactly in the same position. This corner A is made out of pulp board, of the thickness of the block, and paper tacked on it, so that each succeeding block will register accurately (see illustrations on p. 89).

This type of printing is used when the block is underneath and the paper is above. Another method B is employed when the block is placed over the paper. In this case a "finder" is made of cardboard, and two little squares are cut on it, and covered with transparent celluloid. In the center of each of these squares we have a pin-hole so that a pencil-mark can be made through it to the paper on which we print, and each succeeding block can, with the assistance of the finder, be placed in its proper position, thus insuring an accurate print.

When printing in one color ordinary printers' ink can be used. Small quantities can be secured from a local printer, by supplying him with a small container such as an empty ointment jar.

In color printing, printing inks must be used when pure colors are needed. Otherwise white printing ink can be the body color to which oil colors can be added.

The color can be applied to the block with a roller called a brayer, or with a dabber made of leather or silk.

When the block is used over the paper, a letter press becomes almost indispensable, whereas without a press it is better to print with the block under the paper. Having placed the paper on the block, a hard rubber roller is rolled over it, and a print is the result.

In block printing the paper again will take ink better if slightly damp. Some of the Japanese papers seem to be perfect for block printing.

Corner for holding blocks in position

Finder used for accurate register

89

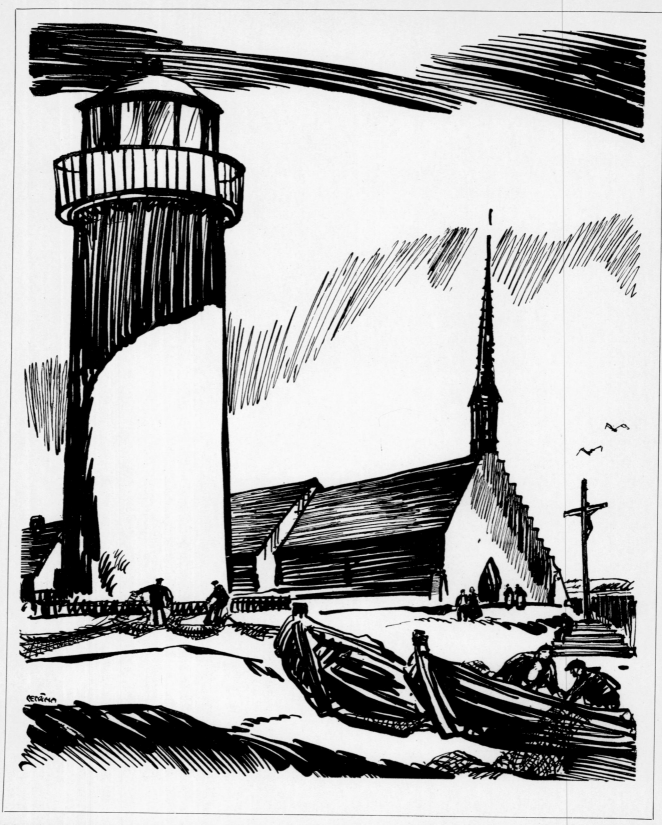

The Lighthouse, Concarneu (Brittany)

Pen Drawing

LINE PHOTO ENGRAVING

UNTIL photography, of which photo engraving is an outgrowth, was invented, reproduction was limited to the direct mediums such as lithography, the wood cut or relief, and engraving. Photo engraving revolutionized reproduction, for it became possible by this new method to reproduce mechanically, and therefore accurately, drawings and photographs and actual objects. It is based on photography to the extent that after a photograph has been taken of the object to be reproduced, a sensitized metal plate over which the negative is placed is exposed to the light, which causes the solution on the plate to wear away where the negative is transparent. Thus the darks are protected, while the whites are exposed to the corrosion of the acid and etched away. Photo engraving includes line and half-tone engraving.

Line reproductions are more faithful copies of the original than half-tone, because no screen is used, and thus the appearance of the reproduction is less mechanical. In a general way the process used in making a line cut is this: The drawing is photographed. The negative is developed as in any form of photography. Next the negative is stripped from the glass plate and placed, in reverse, on another glass plate with other negatives. This makes it possible to handle many drawings or photographs at one time. A polished plate which has been sensitized with an acid resisting solution is now placed in the printing frame, and this glass negative is put over it. Then this is exposed to the light, which affects the parts of the plate over which the negative is transparent by rendering the solution on those portions insoluble. The plate is now removed, developed, and washed, the washing removing the solution in all parts not affected by the light. The back of the plate is now protected with asphaltum or shellac and the etching of the plate with nitric acid takes place. Finally, the plate is mounted to a wooden block in such a way that the block plus the plate will be type high. Assuming that we now have a general idea of the process, let us pass on to the work which takes place before the cut is made. Very fine line drawings, such as made from surface papers, are more satisfactorily reproduced on copper, for copper, being a firmer metal, will retain the fine lines longer. Most line cuts, however, are made on zinc, the artist keeping in mind that a strong, well-defined drawing will not only reproduce better, but will also make unnecessary its reproduction on copper, which is more expensive. Line engraving includes all that will reproduce with a solid black. Nevertheless an illusion of tone can be created either by breaking the line as in dry brush, or by working on surface paper, where

the weight and separation of numerous lines give a tone quality, or again, as in pen work, where a feeling of tone is produced by drawing many fine lines. In working for line engravings it is most important that we should know the purpose to which the drawing is to be put. A line drawing which is to be printed on a fine paper of a coated stock can be rendered very delicately, whereas a drawing which is intended for a newspaper reproduction demands a stronger treatment. The style of the artist also needs to be considered in working for reproduction. The artist who works in a broad manner must work larger than the artist whose work is more controlled, and must be dependent to a greater extent on the reduction of the reproduction to make his work seem more complete. Generally speaking, a drawing is improved in the reduction, for it is brought together more, but, on the other hand, any variation from the original size is bound to be uncertain. It is more necessary that the treatment of a line cut be definite than that it be pure black, although a black line on white paper is the most satisfactory. However, any drawing which is done in a sufficiently dark color, such as red, orange, or brown, will reproduce black.

Top corner 48 Line Screen Half-tone

Below Same Enlarged

Printed from an Electrotype
Courtesy Flower Electrotyping Co., N.Y.

HALF-TONE PHOTO ENGRAVING
THREE AND FOUR COLOR REPRODUCTION
PHOTO LITHOGRAPHY BY OFFSET

THE steps toward making a half-tone engraving from anything that will photograph, whether it be drawing, painting, or the object itself, are not radically different than for the making of a line cut. The great difference is only in the photographing of the object or subject—which must be reduced from actual gradation of tones, to small dots that will produce this illusion. To obtain this, a half-tone screen composed of two pieces of glass plate, each with parallel lines engraved on it, are cemented together so that the engraved and opaque lines cross each other at right angles, forming a screen. The number of lines to the inch on the glass screen give the number of the screen, which generally runs from 50 to 175 to the inch. The glass screen is placed in the back of the camera, closely in front of, but not actually in contact with the prepared and sensitized glass plate in the plate holder. Then when the exposure is made the glass plate, which is to be the negative for the copper plate, registers the object or drawings through this fine screen, and the tones are divided and reduced to dots of varying sizes (within the limits of a specific screen dot) according to their light or deep value.

The chemical and mechanical treatment before and after photographing for the half-tone differ very little from the line or zinc cut, except that half-tone engravings are usually made on copper. There are two reasons for this. One, that the dots produced by the screen to the negative and then from the negative to the copper plate are so fine, that they would not stand the action of the acid when the plate is etched. Two, that were this possible—as when the more open screen is used for coarser work—the zinc being a softer substance than copper, would not in the printing support these very fine dots very long.

Both the more open and coarser screens, as well as the very fine which can only be used on coated stock, are never as clear and crisp as a line cut which shows the whites, as white, and not a veiled white as in a half-tone. This, however, can to a degree be overcome by what is known as the High-light Half-tone, produced either

95

Continued on page 98

PHOTO ENGRAVINGS FROM REPRODUCTIONS

When a reprint is desired of a picture and neither the original nor the cut is available, an engraving can be made from the reproduction itself. From a line engraving, providing the impression is good, this is a simple matter, since it does not differ from the photographing of an original. On the other hand, when an engraving is desired from a half-tone reproduction, this is possible by one of two ways. The first is by making a line cut of the half-tone reproduction. This is particularly successful if the screen used was not too fine and the dots which give the illusion of half-tone are clear and divided. The above illustration was reprinted in this manner from 133 screen half-tone reproduction. This is about the limit for a satisfactory line cut made from a half-tone. The coarser the screen, the better the result, that is to say, a cut from a reproduction made by a 50- to a 100-line screen is better than when a screen from 100 to 150 dots to the inch was used.

A second way of making a cut from a reproduction is to proceed as if working from the original and using the same screen as was used for making the reproduction. When this is carefully done, this will cover dot for dot and the result will not be very different from the reproduction from which it is made.

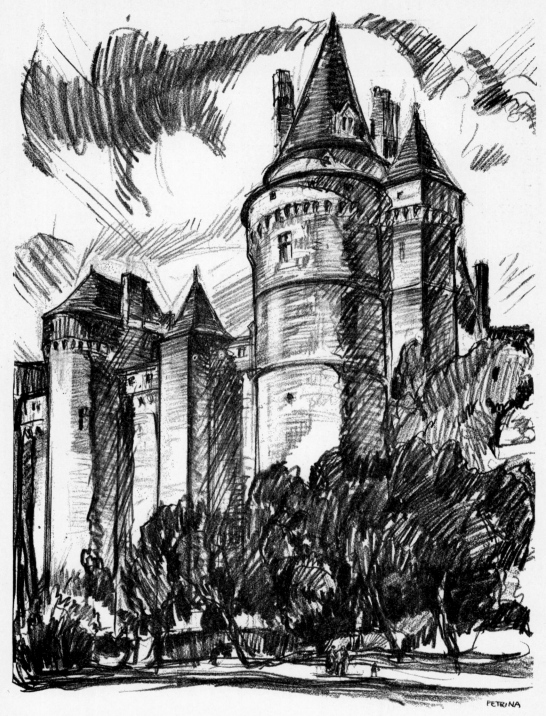

PETRINA

The Château, Vitre, France

A High-light Half-tone reproduction
by the Bassani Process

97

by etching out the whites by hand, something that needs to be most skilfully done, or by a drop-out process invented by Laurent Bassani and named after him (see illustration on p. 97).

Color Process Work

When greater variation of color than is possible by a flat or Ben-Day plate is required, when realistic rather than the two-dimensional effect is preferred, process color reproduction is better, although its cost in the making and its limitations in the printing are at times forbidding. Color half-tone work, which is known as process work, is obtained in the same manner as the ordinary half-tone, except that because the colors must be separated, and each color represents a plate, the process is more involved. The problem of the color engraver is to separate color just as the prism does. However, since this type of color work is done by the half-tone process, no more than three color plates are required. The seven spectrum colors have been reduced into their simplest form—red, yellow, and blue. Color reproduction by this method is called the three-color process. A red, a blue, and a yellow half-tone plate are made of the colored copy, each plate registering completely the values and intensity of one of the colors as it is distributed over the copy.

In process color work the blending of color is so well accomplished, that red, yellow, and blue will give almost every range.

The preparation for this is similar to the half-tone process, plus the necessity of first separating the colors in making the plates, and later re-uniting them in the printing.

Two, three, and four color separations require a negative for each separation. A separation of a color to the negative from the painting or object is obtained by the use of a color filter. The color filter consists of stained celluloid placed in or behind the lens.

The color filter is of a complementary color to the primary color to be photographed. For example, when one wants to photograph the red in a picture, a green filter, which will allow the yellow and the blue to pass, is used. This filter stops the red and registers it on the plate as a black or gray, depending on its intensity. For blue, the orange filter is used. The orange allows red and yellow to pass, but retains the blue even when it is not a pure color but only a component of other colors, such as purple or green. Besides color filters, the registering of true values is assisted by the use of orthochromatic plates which are more sensitive to colors as values.

Two-color work is more usual in line or zinc engraving than in process work. Two-color process work, or duograph as it is sometimes called (see p. 12), is produced

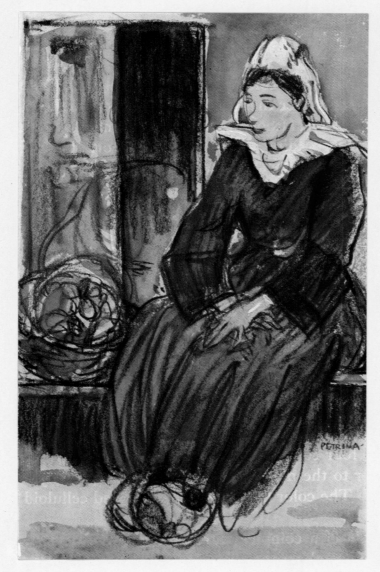

Breton Market Woman Three-color production

by photographing the copy for two colors. Two negatives, each registering the value of one color, are used in making the copper plates, which when printed together, but not at the same time, produce two colors and the combination of two colors.

Theoretically, if not actually, three colors produce approximately any and all colors. The three colors for this purpose are the three primaries, red, yellow, and blue. In order to obtain a deep purple to take the place of black, when these three colors are superimposed, it is necessary to use stronger colors than when black is added. When a well-defined and contrasting drawing is reproduced by an engraving that is properly made and well printed, the difference in the omission of black is not noticeable. (See illustration on p. 99 of the Breton Woman, an excellent example of a three-color reproduction.)

Four-color work is generally the addition of black to three-color process work, thus making it a four-color reproduction (see following five pages). The addition of black makes possible the use of brighter and clearer colored inks, since deep inks are not needed to produce the illusion of black when superimposed.

Since brighter and clearer inks can be used, and because stronger and richer values are obtained with black, black will generally, if not always, improve the reproduction, though it represents one extra printing, and the making of four plates instead of three. The addition of black not only permits the use of clearer colors, but it will produce neutral shades quite impossible with color alone; this, and the fact that more strength and unity are added by its use, make it valuable when quality and not cost is the main consideration.

Photo-offset

Photo-offset (indirect method of reproduction) is a process of printing from a flat surface. By this process line work and screened photographs or drawings are reproduced from the copy, and half-tones can be printed on rough papers. The results of offset printing are softer and less mechanical in appearance than those made from a direct impression.

Photo-offset is a combination of photography and lithography (see illustration on p. 107). In the negative making, the steps are the same as in line or half-tone photo engraving (see Line and Photo Engraving).

In making the plate for this type of printing, the negatives are assembled on a ground glass table and made to occupy the press area; allowance is made for trim, margins, etc. The negatives are held together by an opaque paper of goldenrod color. After retouching and opaquing the negatives, the unit is ready for the making of a plate. A metal plate, either zinc or aluminium, which has been previously

Continued on page 106

Yellow Plate of a four-color reproduction

8—(E. 12)

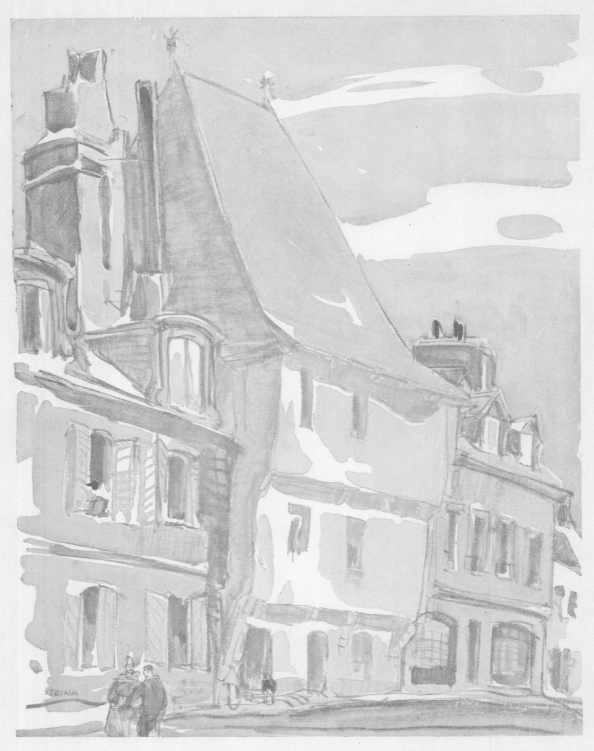

Red Plate of a four-color reproduction

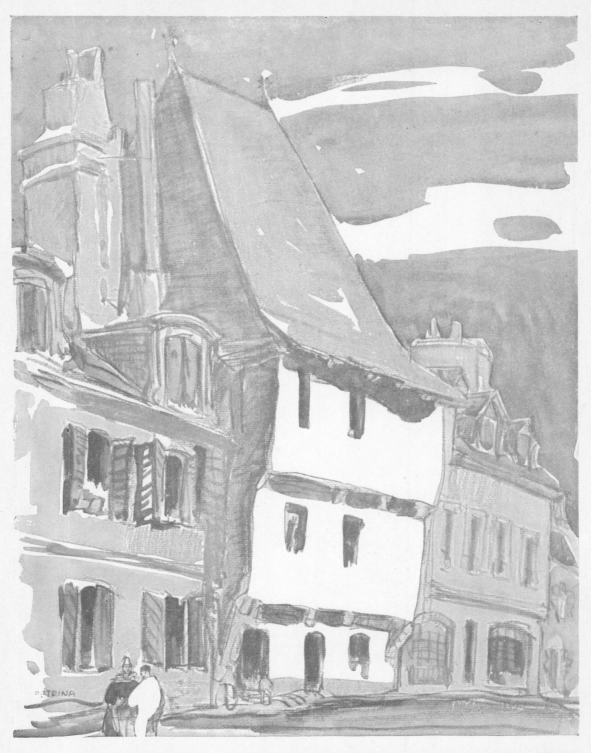

Blue Plate of a four-color reproduction

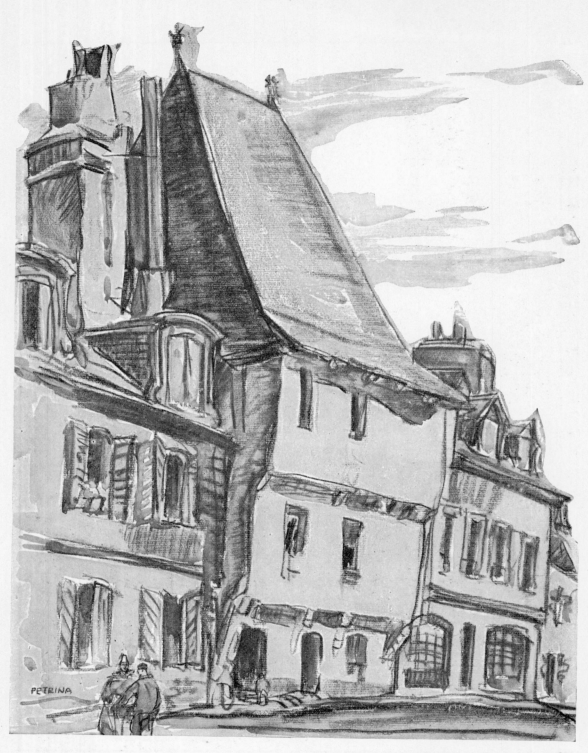

Black Plate of a four-color reproduction

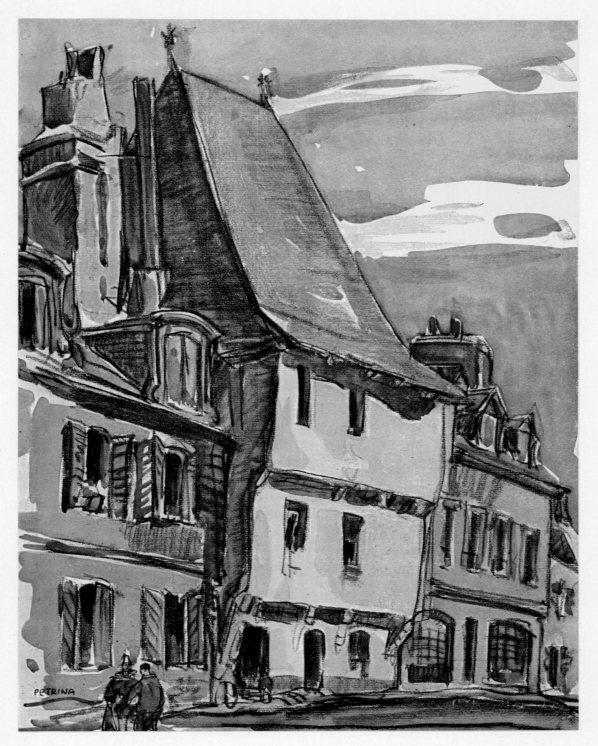

White House, Brittany, France

A reproduction printed with the four preceding plates superimposed

grained, is made chemically sensitive to light (strong arc light, not daylight). This sensitive chemical is insoluble to light but soluble to water. The assembled negatives are placed over this sensitized plate, which in turn is placed in a vacuum printing frame to insure perfect contact (the principle being exactly as in making a photographic print from a film), and is then exposed to the arc lights. After proper exposure has been made, the plate is removed and coated with a greasy substance called "developing ink," and is then placed under a stream of cold water and developed. This developing leaves a black impression on the surface of the plate where the light passed through the negative. This metal plate is in turn retouched and made perfect either by removing spots with a snake stone, or by adding with touche ink. When this is completed, the plate is cleaned and made ready for the press.

The plate is then put on the press by clamping it around a cylinder. As the press turns, the plate is brought into contact with another cylinder which is covered with a heavy piece of rubber called a "blanket." At this point we have the lithographic principle (see Lithography).

The plate now comes in contact with dampers, or water rollers, which moisten the entire surface of the plate. The water is repelled by the inked surface, but is retained by the rest of the plate. The second set of rollers to touch the plate are the ink rollers. The water retained by the plate will repel the ink of the rollers, whereas the work which is a greasy body will retain the ink and print. By this action of grease repelling water it is possible to print only the work, and not the entire surface of the plate.

The copy prints in reverse on a rubber "blanket." The paper fed to the press comes in contact with the rubber "blanket." The work on the "blanket" is "offset" to the paper. Thus we have indirect reproduction or Photo-offset.

For color Photo-offset, the principle remains the same, except that separate negatives and separate metal plates are required for each color.

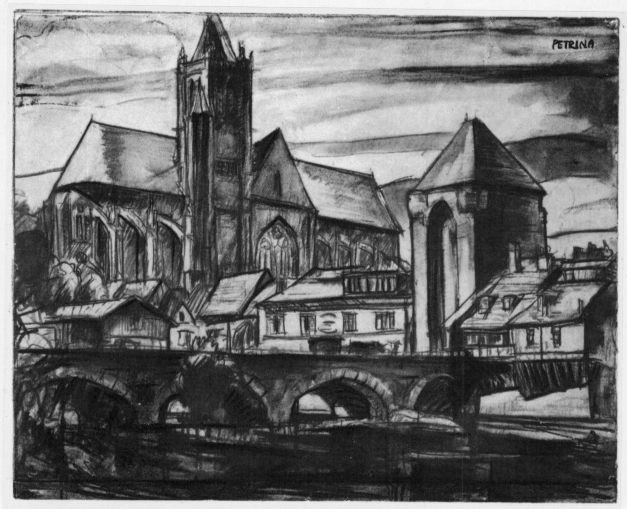

MORET-SUR-LOING, FRANCE

Reproduced by Photo-Offset Process, by
Polygraphic Company of America, New York, N. Y.

The above is an excellent example of the soft richness of photo-offset. Its possibilities for artistic reproduction are emphasized in this illustration by the fact that this half-tone is printed on rough paper. The original drawing was in Charcoal on Manila paper.

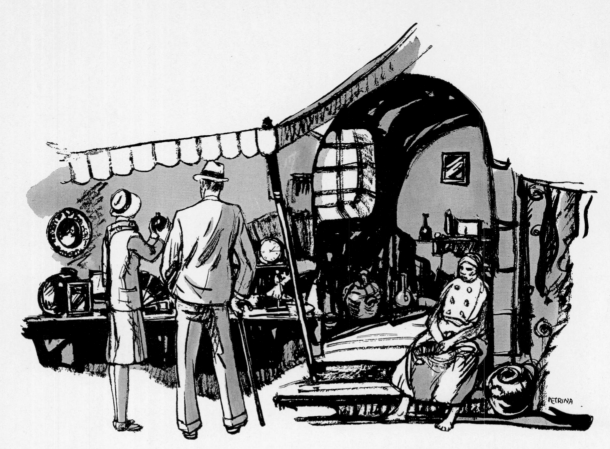

The tones in this brush drawing were produced by the use of Ben-Day

No. 324.—6¾ x 11. No. 325.—6¾ x 11. No. 326.—6¾ x 11. No. 327.—6¾ x 11.

No. 329.—9¼ x 14¼. No. 330.—9¼ x 14¼. No. 331.—9¼ x 14¼. No. 332.—9¼ x 14¼.

No. 334.—9¼ x 14¼. No. 335.—9¼ x 14¼. No. 336.—9¼ x 14¼. No. 338.—6¾ x 11.

A few Examples of Ben-Day grain stipples and textures

BEN-DAY, ELECTROS, MATS, etc.

WHAT is commonly known as Ben-Day is a process, invented by Benjamin Day, for applying tints or designs to line drawings, either to the original drawing, or on the lithographic stone or the metal plate before etching. The method somewhat resembles the printing of a design from a rubber stamp. Ben-Day films are sheets of flexible gelatine stretched on a wood frame, and have a design or tint in relief on the outer side. A roller, inked with an acid-resisting ink, is rolled over the raised side of the film; the film is then placed over the surface which is to receive the design, and the transfer made by pressing the back of the film, which is smooth, with a roller or a burnisher, depending on the character of the design. A light tint may be laid with a rubber roller, but a heavy design needs the local pressure of a burnisher to get solid blacks. Printing the design in etching ink, which is acid resisting, protects the metal from the acid used in etching, and leaves the design in relief after the etching has taken place. When only sections of a printing plate are to be treated, the practice is to take a solution of gamboge, a gum that is soluble in water, and this is painted over the parts where Ben-Day is not desired. The Ben-Day design will print over the whole plate, but after the film work has been laid, the plate is washed off in water. The gamboge, being soluble, will wash off the plate, taking with it the design that was printed over it. Where the design was printed on bare metal, it will stick, leaving the design only where wanted.

Ben-Day charts showing about two hundred tints can be seen at almost any engraving plant.

When it is desired to mark a drawing for Ben-Day treatment, the part where the tint is desired can be colored with a very light blue wash, or left blank and the number of the tint written in with blue pencil. Only blue, which does not photograph, should be used. Better still, paste a thin sheet at the top of the drawing, so that it lies down flat on the drawing. Trace out on this overlay the outline of the parts where tinting is desired, and write the number of the film inside the outlines. This sheet may be folded back when photographing the drawing. In addition, a note on the margin of the drawing indicating whether light, medium, or dark tints are required will help the engraver to determine these tints, or the artist can, in opaque color, which is more even than water-color, indicate on the border of the drawing the approximate value he wishes the Ben-Day to be. Where the number of the

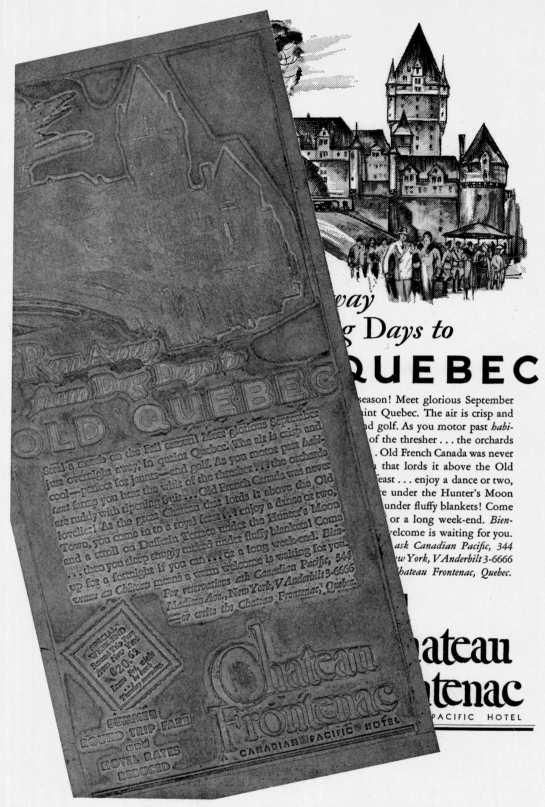

Matrix, and print from Stereo of same

film is given, this is unnecessary. The notations must be made on the margins where they will not show.

When Ben-Day is used, the paper on which these plates are printed should always be considered. Generally speaking, a coarse Ben-Day tint will print on the average surface, while a fine texture, which is produced by fine dots, must have a smooth coated surface.

Ben-Day Effects

Ben-Day effects can be also secured by using transparent sheets which have dots and patterns very similar to Ben-Day. These have an adhesive side to them which, when placed over a drawing, will adhere. The sheets can be applied over the light or the dark areas of the drawing, depending on the effect desired, and with a sharp knife they can be trimmed to cover only certain areas, and the unwanted film can be pulled off and removed.

Because these sheets are transparent they allow one to see the drawing under them, and permit the artist to trim off the unwanted parts after they have been applied to the drawing, and in so doing be more accurate than if a printed pattern on opaque paper were used. Several of these sheets can be placed to overlap each other, and a more intricate design obtained in this manner. After these sheets are applied over the drawing, it is photographed in the usual manner.

Electrotyping

Electrotyping is a process of duplicating plates without duplicating their cost, the cost of an electrotype being much less than the cost of making an original plate. Electros, as they are called in the trade, are faithful duplicates. They are made from wax or lead molds, produced from the original plate. In this manner not only photo engravings, but any form of wood engraving, linoleum cuts, etc., can be duplicated.

Once the mold is made, it is placed in an electroplating bath, hence the word "electro." A shell of copper forms over its entire surface. This shell is later removed from the mold and filled with metal, and is from then on treated like an ordinary engraving.

Electros are made either as a protection in case the original is lost, injured, or worn, or to speed up the printing by adding to the original plates as the occasion requires. They are especially valuable in duplicating wood-engravings, which would not endure the pressure of the power presses. In doing this, the original

wood-engraving or wood-cut, which represents a great deal of care and time to the artist, is not put to the risk of being injured or worn in the printing.

Matrices

Matrices, or what are commonly called "mats," are molds made of a composition which permits the casting of type metal from which stereotypes or stereos are produced. The molds or mats are flexible and can be curved, which allows the casting of them to fit on the cylinders of a rotary press. These mats or molds do not reproduce the clean casting that is possible from a wax mold when making an electro, and therefore they are better suited to a very open half-tone or line cut.

When working for reproduction the artist should know, whenever possible, how and where his work will be reproduced. By studying and planning accordingly, no noticeable changes will take place in his work in the reproduction. Generally speaking, clean black lines not too fine nor too close together suffer least, and a wood or linoleum cut would suffer very little. However, solid blacks are not usually permitted in newspaper reproduction, for they pick up too much ink, and affect the layout of the page too greatly, so that, too, must be considered when planning to have a successful cut, electro or mat.

The artist should bear in mind that for every original seen, hundreds if not thousands will see his work when reproduced, and at least as much thought should be given to its reproduction as is given to the making of the original.

WORDS AND TERMS USED IN PHOTO ENGRAVING

(Copyrighted by the American Photo-Engravers Association, and reprinted by permission)

Aberration. Convergence to different foci. Term used to denote faulty or incorrect focus of lines and colors.

Achromatic. Without color. A lens which refracts light of all colors equally is said to be achromatic.

Acid Blast Etching. A process for the mechanical etching of photo-engraved plates.

Acid Blast Machine. A mechanical contrivance in which an etching solution is driven by powerful blowers through a system of sprayers arranged in the base of an acid chamber and directed into the surface of the plates held in an inverted position against the spray in the upper part of the compartment.

Actinic. Chemically active but mostly invisible light rays as distinguished from visual rays. The rays which act upon photographic emulsions.

Air Brushing. A method of placing smooth, tint surfaces on a photograph or wash drawing by an invention by which a liquid pigment is blown in a spray through a tool by aid of compressed air.

Anchoring. Fastening plates on to wood blocks by metal columns through the back of block.

Aquarelle. French word for a water-color painting made in tints of pure color, without the use of white or other body color.

Autochrome. Lumiere plate used for making photographs in natural colors.

Backing Up. Covering the back of a photographic plate with an opaque, light-absorbing medium, to reduce halation. Also, a metal backing soldered to printing plates to make them 11 points (0.152 in.) thick for use on patent blocks or printing bed bases.

Base. Synonymous with block.

Bassani. The name of the inventor of apparatus applicable to a process camera by which the half-tone screen may be decentralized and rotated during exposure.

Bearers. Excess metal around or within the printing area of a plate. Also called dead metal. Also strips of metal sometimes placed at sides of plate when hand inking and proofing.

Benday. A method for laying tints (composed of dots, lines, and other textures) on negatives, metal prints or copies. Benday was name of inventor of process.

Benday Plates. Plates made by laying tints on copper or zinc and etching them to produce textures, colors or combinations of colors when printed.

Bevel. Machined straight edge margin of plate used as flange for mounting plate on block.

Beveling. Plates that are rectangular are put on beveling machine making an eighth of an inch channel, this being used to nail plates on wood. Black and white lines are also put on plates with this machine.

Bite. Trade term for etching on metal plate.

Black and White. Term used to distinguish between monochromatic and polychromatic subjects.

Black and White Line Finish. A fine black finish line separated from the edge of the half-tone by a white line of equivalent thickness.

Bleach Print. A silver print used as a basis for a pen drawing. The photographic tones being readily bleached out by the application of bichloride of mercury or other bleach.

Bleed. Area of plate or print extending beyond edge to be trimmed.

Block. Wood or metal base on which plate is mounted.

Blocking. Fastening the plate upon a wood base.

Blocking Flush. Trimming block flush on top, bottom, sides or all around, so that printing surface is flush with the block.

Blue Print. A sensitized photographic paper yielding a blue and white print upon development; also trade name for a stained blue unburned print on metal.

Border. Finishing line or design on plate.

Burr. Metal turned up above printing surface by routing cutter or other tool.

Burnishing. To rub plate with polished steel burnishing tool to darken printing area of plate, by spreading dots.

Camera. Light-tight box, consisting usually of front and rear element joined with bellows, and provided with means for attaching lens at front end and plate-holder at rear end.

Chalk. Magnesium carbonate in block or powder used to fill in etched areas of plate to show tone values.

C. P. Abbreviation for "Chemically Pure."

Chewed. Shop term for the ragged effect of the lines of a plate caused by acid working through an imperfect protection.

Chromium Plated. Printing plates upon which an electrolytic deposit of chromium has been made to provide greater wearing qualities.

Circle. Term denoting shape to which plate is to be cut. (Plates so ordered should carry clear instructions as to finish—such as: no line, hairline, no white, hairline, fine white inside. "Special line" should be accompanied by sample.)

Coated Paper. Paper having a wood-pulp or rag base, coated with clay composition on one or both sides.

Cold Enamel. Bichromated Shellax or other colloid. An acid resist photographically applied to metal. Does not require heating or burning in.

Collodion. Pyroxylin (nitrated cotton) dissolved in alcohol and ether.

113

Collodion Emulsion. Collodion containing silver haloid in suspension.

Collodion, Negative. Collodion containing haloid salts used for wet plate photography. Requires sensitizing in silver bath.

Collodion, Stripping. Plain collodion containing castor oil used for coating wet plate negatives to strengthen film before stripping.

Color Artists. The term applied in some localities of the photo-engraving industry to designate Film-layers or those skilled in the laying of tints from the Benday or similar patterns. The more fitting designation is Benday Artists and the work of their department is generally known as Benday work, although in many cases it may not involve the actual laying of tints, some classes of work being largely of a solid color nature involving the "painting in" incident to the separation and diversion of a color scheme into a number of color plates.

Color Filter. A colored substance such as glass, dyed gelatine or colored solution, used to absorb certain colors and transmit others.

Color Guide. Graphic instructions for color rendering or placement.

Color Proofs. Proofs of color plates combined and registered.

Color Proofs—Progressive. Single proofs of each plate of a color set and combined proofs showing result of each successive color printed and assembled in printing sequence.

Color Separation. Separation of colors in negative making by means of color filters, and in plate making by means of drawing upon the plate with acid-resisting paint.

Color Work. General term for color plates to print in two or more colors.

Color Work—Benday. Any Benday plate used in conjunction with a color set.

Color Work—Process. A set of two or more half-tones made by photographic color separations.

Combination Plate. Half-tone and line work combined on one plate and etched for both half-tone and line depth.

Combination Plates—Color. Plates made by the use of a key plate and color plates, either half-tone or line, to be printed in two or more colors.

Complementary Colors. The complement of any color is the combination of the other colors completing the spectrum.

Connected Dot. Half-tone dots in negative or plate which are joined together.

Contrast. The quality of an illustration possessing a wide difference in tone values. One in which the high-light and shadow tones are strongly in evidence.

Copper Etching. The act of etching a copper plate. Also an etched copper plate.

Copy. The original, be it photograph, drawing, painting, design, object or anything that is in process of reproduction for printing purposes.

Crop. To cut off an edge or trim.

Cross-hatch. A series of parallel lines crossed with others at any angle.

Cross-line Screen. Half-tone screen having lines crossing at right angles as distinguished from straight line screen having no cross-line.

Curved Plate. One that is backed up and curved to suit the cylinder of a rotary press.

Cut. An obsolete synonym for photo-engravings or plates. Originally referred to as wood cuts.

Dead Metal. Excess metal around or within the printing areas of a plate. Also called bearers.

Deep Etch. Sinking or "running down" the open parts of a photo-engraved plate to acquire the necessary printing depth.

Deep Etching. Bites additional to the first bite given line plates or coarse screen half-tones.

Detail. Minute or specific subdivisions of an image.

Digging Out. Removing small places in metal plate with hand tools.

Dimension. Width of an image measured horizontally or depth measured vertically.

Dimension Marks. Points indicated on a copy outside the area of the image to be reproduced, between which size of reduction or enlargement is marked.

Direct Half-tone. A half-tone for which the screen negative is made by direct exposure of the article itself, and not from a photograph or drawing.

Distemper. A form of painting done with body colors mixed with white and a sizing medium, usually a glue size. Commonly used by scenic artists for theatrical work.

Dots (Half-tone). Minute, symmetrical, individual subdivisions of printing surface formed by half-tone screen.

Double Print. Prints from two different negatives occupying fixed positions on the same piece of metal but not necessarily superimposed.

Drawing. Finished work of the artist (either by brush, pen or any other medium). It is the copy from which reproduction is made direct. It contains every detail desired to show in the finished photo-engraving.

Drop Out. When the highlight dots of a half-tone are etched away they are said to be "dropped out."

Drop Out Negatives. Half-tone negatives in which highlight dots are so exposed as to prevent their printing on the metal. When the plate is etched the highlights "drop out" and can be deep etched.
Correct name is "Highlight" negative.

Dry Brush Drawing. A drawing made with a brush and only slightly moistened India ink, the aim being to secure a vigorous execution of a character between a bold crayon drawing and pen work. A difficult and highly distinctive technique.

Dry Plate. Photographic plate on which light sensitive film is dry.

Dry Plate Negative. Term customarily used to denote continuous tone negative as distinguished from half-tone negative.

Duograph. Two half-tone plates at different screen angles made from one monochromatic copy and printed to produce two-tone effect. Key plate printed in dark color, second plate, etched flat, printed in light tint.

Duotype. Two half-tone plates made from the same negative. One etched for detail (Key plate) the other flat

ART WORK · HOW PRODUCED · HOW REPRODUCED

to print in light tint. Unless great care is used in printing, both plates being made from same negative, a decided moire or screen pattern will result. A poor substitute for Duograph.

Duplicate Plates. Plates made from the same negative as the original plate. Etched and finished in the same manner.

Electrotype. A plate made by electrolytically depositing metal—copper, nickel, etc., on a mold of wax or metal taken from the original plate or (wood cut).

Electrolytic Etching. Electrical decomposition of metal unprotected by the resist.

Eleven Point Metal. Metal ·152 in. thick. Sometimes called heavy metal.

Ellipse. Denoting shape of printing surface of a plate. A regular oval.

Em. Printing term denoting the square of the body of type. 12 point ems are exactly one-sixth of an inch (or 12 points) in width and depth. Sometimes erroneously called "Picas." One PICA is slightly less than 12 points.

Embossing Plate. A plate cut or etched below its surface into which the paper is forced for the purpose of raising the image of the printed surface.

Emulsion. Trade term for sensitive collodion having silver salts in suspension.

Enamel. Carbonized glue or shellac acid resist.

Enamel. A sensitized coating flowed or spread on the surface of a metal plate to receive the image by light transference through a line or half-tone negative. When developed and burned in, the enamel hardens into an acid resist protecting the image during the etching process.

Engrave. To cut, etch or incise a surface.

Engraver. Trade term employed to designate the artisans who execute the hand tool work on a plate. (See also Finisher.)

Engraving. Executing hand work on a plate, also a broad term for any form of printing plates produced by hand, photo-mechanical or etching process.

Enlargement. A reproduction larger than full size of copy.

Etched Depth. Distance measured vertically from flat printing surface to bottom of etched area.

Etching. Chemical or electrolytic disintegration of metal also the trade name of a printing plate in which the picture or design in positive or negative form is incised by the action of acid. The process of corrosion or disintegration of metal when subjected to the action of an acid bath.

Etching Ink. An ink soluble in water and containing ingredients which combine with powdered resin to make an acid resist.

Etching Machine. Mechanically-operated device to agitate etching acid and to distribute action evenly on face of plate.

Exposure. Subjecting a sensitized plate to the action of light. The duration of time of subjection.

Face. Denotes film side of negative or printing surface of plate.

"Fake" Process. An unfounded and obsolete term for half-tones printed in two, three or four superimposed colors, made from monochromatic copy with suitable screen angles, the colors being constructed by the photo-engraver to simulate effect of color separations.

Film. A thin body of collodion, gelatine or other substance generally employed as the vehicle for a sensitized photographic preparation. The photographic negative or positive.

Filter, Color. Transparent dyed colored substance either dry or liquid, for transmission of specific colors and absorption of others. Used in photography for color separation and for transmission of specific colors from copy to photographic plate.

Fine Line. A thin black finishing line enclosing the image on a plate. Also called hairline.

Fine White Line. A thin groove, tooled or etched into the printing surface of a plate. Also called hairline white.

Finish. Term used to designate treatment of outer edges of plate such as: square finish, hairline finish, vignetted finish, etc.

Finisher. The artisan who executes the final re-etching, engraving, tooling or burnishing preparatory to final proofing. Properly termed engraver.

Finishing. The final refinement of a printing plate and the removal of minor defects by hand tooling methods.

Fixing. Chemical removal of unexposed silver salts from developed photographic plate or print to prevent further action of light thereon.

Flat. Trade name for metal or the glass on which a number of half-tones or line negatives have been stripped or printed or etched. The appearance of a picture that is lacking in contrast or one possessing a very narrow or limited range of tone values is called flat.

Flat Etching. The first period of etching on a half-tone plate wherein the entire surface to be etched is submitted to the acid for a sufficient time to acquire the necessary "printing depth."

Flat Plate. Etched plate with poor contrast—opposite of Contrast.

Flat Proof. Proof made from finished or unfinished plate but without make-ready of any kind.

Floating. A term used to express the handling and placing of photographic films when stripping.

Flush Blocking. Trimming mounted plate and block flush with printing surface.

Flush Trimming. Trimming unmounted plate flush with printing surface.

Focus. The point in the camera at which the converging rays of light passing through the lens from the original coincide to form a sharp image.

Four-color Process Plates. Same as the three-color process with the addition of a grey or black plate.

Free Silver. Silver nitrate solution on surface of wet plate.

Frisket. A paper mask used to cover up dead metal or bearers when proofing.

Fuzzy. The appearance of a proof due to slurred impressions. The appearance of a picture that lacks sharpness. The appearance of a half-tone of irregularly etched dots.

Gallery. That part of an engraving plant used for making photographic negatives, etc. Its equipment.

Gamboge. A gum, soluble in water, used for stopping out areas on metal prints preparatory to laying tints.

Glue Top. The burned in enamel or acid resist on a plate.

Gouache. French word for a water-color painting made with body color, and some kind of size or water soluble gums.

Grain Box. A cabinet enclosing line bitumen dust which, when agitated, and allowed to settle on the face of metal and burned in, forms a granular resist.

Grained Plate. A plate etched after having been coated with a granular resist.

Graver. Tool for doing engraving on a plate.

Gray. A term used to express the appearance of a picture lacking in brilliancy or rendered wholly in middle of low tone value.

Guide, Color. A sketch or color indication used when making color plate from uncolored copy.

Hairline. The finest line, either black or white, which can be etched or engraved on a relief plate.

Hairline Finish. A fine black finish line in contact with and bordering the edges of a square finished half-tone.

Half-tone. A relief photo-engraving, the negative for which has been made by photographing a copy through a half-tone screen. Also, the printed impression from a plate so made.

Half-tone Dot. An individual point of formation in negative or plate, characteristic of the half-tone screen.

Half-tone Negative. Photographic negative made by photographing a copy through a half-tone screen.

Half-tone, Outlined. A half-tone with the background outside of the object entirely cut away, leaving a definite edge without shading or vignetting—a silhouette.

Half-tone, Outlined and Vignetted. A half-tone in which part of the background is cut away and part vignetted.

Half-tone Plate. A relief plate made by a photo-mechanical etching process employing the principle of the half-tone screen whereby all gradations of tone values in the copy are reproduced in the plate by variations in the formation and size of minute dots of geometrical arrangement obtained primarily in the negative by the interposition of a cross ruled screen.

Half-tone Process. The method practised for production of half-tone plates.

Half-tone Screen. A grating of opaque lines on glass crossing at right angles, producing transparent square apertures between intersections.

Half-tone Square Plate. A half-tone in which the outside edges are rectangular and parallel; may be with or without the single black line border.

Half-tone Tint Negative. Negative made by photographing one sheet of white paper through half-tone screen.

Half-tone Vignetted. A half-tone on which one or more of the edges of the object are shaded from dark tones to pure white.

Hand Press. Proofing press operated by hand.

Hand Work. Tool work or extra etching, or any work done on copy, negative, print or plate by hand.

Hard Vignette. One not softened off to the point of invisibility, but exhibiting a delicate but definite printing edge.

Highlight. The light areas of a tone copy. The smaller disconnected dots of a half-tone. Abbreviation for highlight half-tone.

Highlight Half-tone. A plate made from a half-tone negative wherein the highlight dots have been so exposed and etched that they will not print on the metal.

Half-tonometer. A device for measuring the depth between the dots of the printing surface of half-tone plates.

Image. The picture of the copy shown on the ground glass; or the concrete reproduction of a copy on any medium.

Insert. Term applied to an extra copy, also to negative therefrom when the latter is to be inserted into another negative before plate is printed and etched.

Inserting. The fitting of one negative into another or the assembling of a number into a definite relationship to each other by the accurate cutting and fitting of the photographic films. Usually wet plate films can be thus advantageously handled. Collodion emulsion films can be handled in like manner.

Intaglio. Countersunk or depressed image. Incised lines instead of raised or in relief.

Intaglio Etching. Etching down the lines or dots in a plate instead of etching down the areas surrounding them. The resist for intaglio etching is printed from a positive instead of a negative.

Intaglio Print or Proof. Proof made from an intaglio etched plate. The ink being rolled into the etched lines or dots and wiped off of the surface.

Isochromatic. Same as orthochromatic. Photographic emulsion sensitive to blue, green, and yellow, but not to red.

Jig-saw. A narrow thin saw blade, vertically mounted between the ends of two arms which move up and down reciprocally. Used for irregular sawing and for mortising blocked plates.

Joint. The line or point of contact between joined negatives or plates.

Journeyman. Master craftsman who has served full period of apprenticeship.

Key Drawing. Copy composed of guide lines only.

Key Plate. The plate of maximum detail in a color set, to which other colors are registered.

Kill. To cancel, to discard, as to kill a plate.

Laminated Wood. Blocking wood consisting of several thin layers of wood glued together with the grain crossing alternately.

Laying Tints. Trade term for printing Benday or similar tints on metal before etching.

Lens. An assembled arrangement of special glass segments ground and fitted together to form a complete unit. Used in photographic processes for the collection, direction, and distribution of light rays.

Levy Screen. The half-tone screen as developed and manufactured by Max Levy.

Light Absorption. The property of absorbing light or any of its component color waves.

Light Reflection. The property of reflecting light or any of its component color waves.

Line Copy. Any copy suitable for reproduction by a line plate. Any copy composed of lines or dots as distinguished from one composed of tones.

Line Drawing. A brush or pen drawing in which all elements are of full strength of medium used. A drawing free from wash or diluted tones.

Line Engraving. A relief line plate produced from a copy without photographing it through a screen.

Line Etching. The process of etching a line engraving.

Line Negative. A negative made from a line copy and suitable for use in making a line plate. A negative of the same characteristics made from any copy, but without photographing through a half-tone screen.

Line Plate. A line engraving.

Lining Beveler. Machine for beveling straight edges of plates with attachment for tooling straight white lines in borders of plates.

Lumiere. Contraction of "Lumiere Autochrome." A photographic plate made by Lumiere Freres for direct color photography.

Machine Etching. Applications of etching fluid to plate by mechanical means.

Magazine Standards. Individual specifications for the making of printing plates to conform to special printing requirements of publishers.

Make-ready. The preparation and application of underlay or overlay for proofing or printing. Term for the sheet with complete underlays and overlays in position.

Masking. The operation of protecting or blocking out on a copy proof, plate or metal print a definitely outlined area.

Mats. Abbreviation for matrices, *papier mache* or composition, moulds from relief plates or forms.

McKee Process. A process in general terms whereby the make-ready is put in the face of the electrotype plate. In other words, the highlights and shadows are taken care of by the varying heights of the plate on each.

Metal Base or Blocking on Metal. Mounting a half-tone, a line plate or an electrotype on metal type high.

Mezzograph. A photo-engraving made by photographing through a grain screen called a mezzograph screen.

Middle Tones. The various values of a copy ranging between highlights and shadows.

Milling. The mechanical operation of supplying a bevel to the edge of a rectangular or straight edged plate or routing away unwanted metal. (See Beveling.)

Minimum. Size of plate, below which, cost of manufacture remains fixed.

Moire. A formation of undesired symmetrical patterns produced by conflict between half-tone screen and lines or dots of copy. As when making half-tone from half-tone proof or from steel engraving.

Monochrome. One color.

Mordant. An acid bath or corrosive liquid employed to etch metal.

Mortise. Enclosed aperture cut within area of plate or block into which other printing forms may be inserted.

Mount. The base of block on which a plate is fastened to make it type high.

Nailing Machine. Mechanical device for nailing plates to blocks.

Negative. Reversal of values, the white being rendered black and *vice versa*. Also contraction of PHOTOGRAPHIC NEGATIVE.

Negative Inserting. Combining negatives by inserting.

Negative Plate. A line or half-tone plate which prints negative to copy, i.e. with reversed values. Such a plate is made by printing from a positive.

Negative Turning. Stripping and turning negatives over to reverse them.

Newstone. A half-tone, 100-line or coarser, etched on zinc, usually for newspaper illustration but often used in commercial work to be printed on cheap or rough papers.

One Way Screen. A half-tone screen or plate having lines running in one direction only, not crossing.

Opaking. Protecting a photographic plate or transparent medium with a thin non-actinic coating through which light cannot penetrate.

Opaque. A water soluble paint used to block out areas on negatives to make them non-transparent.

Original. Term applied to copy of any kind.

Orthochromatic. Same as Isochromatic. Photographic emulsion sensitive to blue, green, and yellow, but not red.

Outline Finish. A half-tone with the removal of all background surrounding or showing through or within the outline of an illustration.

Outlined Half-tone. A half-tone from which screen surrounding any part of image has been cut away. A silhouette.

Outlining. Going around a cut-out engraving with a No. 6 tint tool; it is done as a guide for the routers.

Over Etched. A plate that has been submitted to the etching process beyond the normal period.

Overlays. Part of make-ready always used in printing vignettes.

Overlay Negatives. Superimposing one negative upon another to obtain results unattainable by one negative.

Overlay in Proving. Built up or cut out sheets used to increase or decrease impressions on specific areas when printing. Placed under tympan sheet **over plate.**

Painting In. The protection of definite areas of half-tone or line plates by the application of acid resisting ink or varnish spread on with a brush.

Panchromatic. Sensitive to all colors.

Patent Base. Metal, sectional blocks with means for holding plates for printing. Same as PATENT BLOCKS.

Pattern. Term used to describe an engraving which will be used only for making electrotypes or other moulded printing plates.

Pattern. The checkered, mottled, moire or watered silk effect produced in half-tone reproductions from originals possessing screen or fine parallel ruled lines. Caused by the pattern of the copy crossing or interfering with the lines of the half-tone screen.

Pen Drawing. Made by pen and India ink, in lines, dots or stipples, being a copy purely of black and white.

Photo. Abbreviation for Photograph.

Photograph. An image resulting from Photography.

Photographic Negative. An image of reversed values, resulting from photographic action of light, all whites being reproduced as blacks and *vice versa*.

Photo-engraving. An etched relief printing plate, in the making of which one or more negatives or positives have been used to produce the required acid resist.

Pin-holes. Small holes in the negative caused by an over-iodized bath or very old collodion. Small holes in print or plate from any cause.

Plate. Any piece of metal bearing in relief or incised into its surface a picture, design or other device from which impressions are to be made by a printing operation.

Sensitized glass, either wet or dry, used in the camera for photography. Also a printing plate.

Plate Holder. Light-tight case for holding photographic plate in position on back of camera.

Plate Thickness. Backing up a half-tone or line plate to the thickness of an electrotype. (0·152 in.)

Polychromatic. Many colors.

Positive. An image of the original object or copy corresponding to same in the scheme of light and shade. An image made by an exposure on a sensitized plate through a negative in contact.

Powdering. Application of resin powder to sides of relief areas of plate to protect them during further etching operations.

Printing. Making impression with inked plate or form, also the operation of making a photographic print, or print on metal.

Printing Depth. The minimum depression in the etched portion of a photo-engraved plate necessary to insure a workable printing quality.

Progressive Proofs. A set of proofs of color plates showing each color alone, as well as in combination with each succeeding color in printing rotation.

Proportion. The relationship existing between the different dimensions of a single object or copy, or the relationship existing between any dimension of object or copy and the corresponding dimension in enlarged or reduced size.

Proving or Proofing. Proving is taking an impression of the plate on paper, after plate has been inked up; a finished proof is one taken by overlay or underlay; a flat proof is taken of plate with all waste metal on.

Cylinder Press Proof. Is a proof taken on such a press as the Claybourn, Hacker or the Vandercook. The impression is made by rolling contact of the plate and paper, instead of squeeze contact (like that taken on the Washington Hand Proof Press).

Quadricolor. Four colors.

Quarter Tone. Term used in some localities for coarse screen plates made by enlarging from smaller half-tones.

Reducing Glass. A double concave lens for viewing copies in reduced sizes.

Re-etching. Supplementary etching to reduce areas of printing surfaces so they will print as a lighter tone.

The work following the flat etching of a half-tone plate, consisting of staging and further etching of different areas of the plate to reduce the various tone values into proper conformity with the copy.

Register. Correct relative position of two or more colors when printed from color plates.

Register Marks. Guides on plates to aid in obtaining register during manufacture and proofing.

Relief Plate. Any plate for printing purposes in which the negative form of a picture is etched, cut or sunk into the plate resulting in the relief presentation of the picture in its positive form.

Reproduction. The process of duplication of pictures, etc., by photo-engraving methods. The product of the photo-engraving process.

Resist. Protective acid-proof coating covering printing area of plate and leaving parts to be etched exposed.

Retouching. Corrective treatment of negative, positive or copy by means of brush, pencil, pen, air brush or other means.

Reverse Plates. Plates which are negative in tone values to copy.

Rouletting. Indenting printing surface of a plate with a roulette to create or modify tone values.

Router. The machine on which the routing of a plate is accomplished by the high speed revolution of a cutting tool operating in a movable spindle head. Also one who routs.

Routing. A mechanical means of removing the unessential metal or wood from any part of a printing plate, or lowering the surface of such parts that are not intended to be printed.

Saw Tooth Edge. Edge of half-tone crossing screen line at angle causing symmetry of dots to break into appearance of teeth of saw.

Scale. A rule of graduated dimensions. A schedule of rates or computations. A table of percentages. A ratio of enlargements or reductions.

Screen. The term used to denote the particular ruled screen to be used for half-tone reproduction. Screens are ruled for practical purposes from 50 to 200 lines to an inch. The coarser rulings are used for plates to suit the conditions of newspaper printing, and the finer ones for the higher printing requirements. The numbers between are more generally employed to meet intermediate conditions. The character of the paper and press work, and to a certain extent the nature of the copy, determine the selection of the most suitable screen to be used in each instance.

Screen Angle. The angle at which two or more half-tone screens are crossed to avoid a pattern as in color work.

Screening. Stripping a half-tone tint negative on a transparent area of another negative.

Screened Line Plate. A plate made from pen drawing by imposing a screen before etching for the purpose of producing a tint effect. It has been found convenient to use the word "Skiagraph" to designate the result of stripping a half-tone negative over a line negative and printing them on metal.

Set-up. Negatives whether all line or all half-tone or both, stripped in a specified position.

Set-up Double Print. To place negatives, generally a line and a half-tone negative on separate glasses, with register marks on each glass, so that metal printer may photo-print both negatives on same piece of metal in position desired.

Shading Machine. Device for holding and adjusting position of shading films for laying tints on negatives or metal prints.

Shadow. The part of a picture obscured by lack of illumination. The darker areas of any copy.

Sharpness. The clear, well-defined appearance of the image or picture.

Shoulder. The projecting ledge on an etched plate created by four-way powdering after the first bite. Any similar projection below printing surface.

Silhouette. A half-tone from which screen surrounding any part of image has been cut away or etched away.

Silhouette Finish. A half-tone with all background surrounding an illustration of simple contour removed from the plate.

Silver Print. Photographic print on paper which has been sensitized with silver chloride salts.

Size. Dimensions expressed in inches or definite terms on a copy is interpreted as indicating the desired dimensions of the reproduction.

Sketch. Usually is made in a rough, quick way with a pencil, crayon or brush, to suggest the composition or style of a prospective drawing, to be completed later. A sketch (or "lay-out") is a preliminary to a drawing, and is rarely, if ever, reproduced direct.

Slug. A hole or tear in negative or print or plate.

Slurred. An impression that is imperfect due to indirect pressure.

Snappy. A term describing a brilliant picture of wide contrasts and wealth of middle tones.

Spotting. Removing black or white spots on plate.

Squared. Designating shape of half-tones all four sides of which can be beveled in straight lines.

Square Finish. A half-tone with an unbroken screen surface finished in rectangular shape with or without border line.

Staging. Protecting by the application of asphaltum varnish or other resist such area of a plate requiring no further re-etching, leaving those parts of the plate surfaces exposed which require additional treatment.

Stain. Image formed by discoloration on copper or zinc print by short immersion in weak acid or alum bath.

Stain Print. A print on metal from either half-tone or line negative immersed in acid for an interval just sufficient to stain the exposed surface. When the print is washed off a distinct image is shown by the contrast between the stained and unstained parts. Stain prints are used as the guide for the laying of the Benday or solid tints for color plates.

Stamping Die. A relief plate engraved or cut on brass or zinc for stamping book covers or similar surfaces.

Stereotype. A plate made by casting metal into a matrix, used generally for newspaper and cheap forms of printing.

Stipple. Generally used in a collective sense to designate any arrangement of dots of regular or irregular formation.

Stopping Out. Covering areas on a negative with opaque to prevent light action or on a plate with resist to prevent acid action.

Stripping. Removing negative or positive film from glass preparatory to turning and inserting.

Sur-print. A print from a second negative superimposed in a definite manner upon the print of the first negative.

Tempera. The oldest method of artistic painting. Probably evolved from a primitive method in distemper. True tempera is painted upon canvas, wood or other surfaces prepared with coatings of gesso, a mixture of slaked plaster of Paris, pure dry zinc white and fine whiting (or the whiting alone), with a thin size made of fine acid-free glue. The colors are usually mixed with a medium composed of egg yolk or egg-white, or casein and body white is freely used. Tempera paintings have a mat surface, unless they are varnished, in which case they look like oil paintings.

Three-color Process Plates. Printing plates produced from colored copy, or objects, to reproduce the picture or object in its original colors by a photochemical separation of the primary colors, and etched half-tone plates to reproduce each separate color, usually printed in yellow, red, and blue.

Three or More Color Half-tones. Same as definition of two-color half-tone, using three or more etched half-tone plates.

Tint. A reduction of a solid color.

Tint Block. a solid plate to be used in printing a light flat color.

Tint Laying. The operation of transferring Benday tints to plates, drawings or other mediums.

Tint Plate. An area of screen, stipple, ruling or other patterns of an open nature.

Tooling. Engraving white lines with a graver.

Top. Acid resist on a metal plate preparatory to etching.

Topping Powder. White resin used to create acid resist on an inked albumen print.

Transfer. Ink impression from etched plate used to make a duplicate impression on another plate.

Transparent Proof. Proof on transparent paper.

Trichromatic. Three colors.

Trimming. Tooling off projecting ledge below printing surface of etched plate. Milling sides of blocks.

Two-color Process Plates. Two half-tone plates made at different screen angles from monochromatic or colored copy by the photo-mechanical separation of colors or by etching, to approximately reproduce the copy when the plates are printed in two contrasting colors.

Type-high. 0.9186 of an inch. A plate is said to be "Type-high" when it is mounted on wood or metal to the proper height to be used on a printing press.

Undercut. The lateral etching of the lines or dots in a line or half-tone plate below the printing surface.

Underlay. Built up or cut out sheets placed under plate to increase or decrease impression on special areas when printing.

Upham Attachment. A flat-bed press with plate cylinder under feed board contacting with impression cylinder.

Plates are curved by a process in which elongation is eliminated.

Velox Print. Name for one of the chloride printing papers made by the Eastman Kodak Co. and sometimes erroneously used as name for similar developing papers.

Vignette. A gradually shaded off edge, from dark to light, as on a photograph or engraving.

A half-tone with the background setting blending into an invisible finish. Due to the gradual reduction in the size of the dots of the background as they approach the printing edges.

Wash Drawing. Made by a brush in washes with a single pigment of black or dark color soluble in water, to be reproduced by the half-tone process.

Water Color Drawing. Same as above, made in washes with a combination of several colors. Reproduction may be by process color half-tone plates or by redrawing and by combination of half-tone with Benday line plates.

Wet Plate. Collodionized glass plate sensitized with silver nitrate and exposed while wet.

Wet Printing. A term applied to one color following another immediately in printing color plates, i.e. one impression is made upon another before the ink has time to dry.

Plates should be adapted to this method of printing whenever information is furnished as to such requirements.

Wood Base. Wooden block used for mounting printing plates.

Wood Engraving. A printing plate in which the illustration is photographed or drawn on boxwood and engraved entirely by hand.

Working Drawing. A perfected drawing of a crudely executed idea or preliminary sketch made for the purpose of reproduction from copy unsuitable for reproduction in its original form.

Zinc. Metal used in etching department. Abbreviation for zinc etching of line plate.

Zinc Etching. A photo-engraved line plate on zinc. Action of acid on zinc.

Zinc Half-tone. Half-tone plate etched on zinc.

Zinc Print. Photographic acid resist photo printed on zinc.

A CLASSIFICATION OF OIL COLORS
IN THREE DEGREES OF PERMANENCE

Class I—Permanent Colors

The Colors in this class constitute Winsor and Newton's "SELECTED LIST": the Labels on Tubes containing them being BRANDED WITH THE LETTERS "S.L." IN RED, to indicate this fact. They are all of good permanence (the list being in this respect at least equal to that issued by any other Artists Colormen), and with the possible exception of—

 1. Aureolin with Madder or Alizarin Lakes;
 2. Prussian Blue with Vermilions or Cadmiums,

they may be mixed together *ad libitum* without injury.

According to some authorities, however, even these mixtures are perfectly safe.

N.B. The word "Permanent," as may be gathered from the footnote, must not be taken to mean *absolutely* permanent. It simply indicates that the colors in this class are sufficiently durable for a self-respecting artist to employ. This is not only the usual, but also the useful sense of the term, for, in most classes of work, it is impossible for a good colorist to rely exclusively on absolutely permanent colors.

Academy Blue
Alizarin Carmine
Alizarin Crimson
Alizarin Scarlet
Antwerp Blue
Aureolin
Aurora Yellow*
Black Lead*
Blanc d'Argent
Blue Black*
Brilliant Ultramarine*
Brown Madder
Brown Ochre*
Burnt Lake
Burnt Roman Ochre*
Burnt Sienna*
Burnt Umber*
Cadmium Orange
Cadmium Yellow, Pale
Cadmium Yellow*
Cadmium Yellow, Deep
Cappagh Brown*
Cerulean Blue*
Charcoal Gray*
Chinese Blue
Chinese Vermilion
Cobalt Blue*
Cobalt Green
Cobalt Green, No. 2
Cobalt Violet*
Cobalt Yellow
Cologne Earth
Cool Roman Orche*
Cork Black*
Cremnitz White†

Crimson Madder
Cyanine Blue
Cyprus Umber*
Davy's Gray*
Emerald Oxide of Chromium*
Extra Madder Carmine
Extra Purple Madder
Extra Ultramarine Ash*
Extract of Vermilion
Field's Orange Vermilion
Flake White†
Foundation White†
French Ultramarine*
French Vermilion
Genuine Ultramarine*
Gold Ochre*
Indian Purple
Indian Red*
Ivory Black*
Jaune Brillant††
Lamp Black*
Leitch's Blue
Lemon Yellow
Lemon Yellow, No. 2
Lemon Yellow, Pale
Light Red*
Madder Carmine
Madder Carmine (Alizarin)
Madder Lake
Mars Brown*
Mars Orange*
Mars Red*
Mars Violet*
Mars Yellow*
Mineral Gray*

Mineral Violet
Mineral Violet, No. 2
Monochrome Tints, Cool, 1, 2, 3††
Monochrome Tints, Warm, 1, 2, 3††
Naples Yellow††
Naples Yellow, French††
Neutral Tint*
New Blue*
Orange Vermilion
Orient Yellow*
Oxford Ochre*
Oxide of Chromium*
Oxide of Chromium, Transp.*
Pale Vermilion
Payne's Gray*
Permanent Blue*
Permanent Blue, Deep*
Permanent Crimson
Permanent Violet
Permanent Yellow
Permanent White*
Pink Madder
Primrose Aureolin
Prussian Blue
Prussian Brown*
Purple Madder
Purple Madder (Alizarin)
Purple Madder, Extra
Raw Sienna*
Raw Umber*
Roman Ochre*
Rose Madder
Rose Madder (Alizarin)

A CLASSIFICATION OF OIL COLORS

Rose Madder, Pink Shade
Ruby Madder (Alizarin)
Scarlet Lake
Scarlet Madder
Scarlet Madder (Alizarin)
Scarlet Vermilion
Sepia
Silver White††

Sky Blue
Terra Rosa*
Terre Verte*
Terre Verte, Olive Shade*
Transparent Gold Ochre*
Ultramarine Ash*
Ultramarine, Light*
Ultramarine, Deep*

Venetian Red*
Vermilion
Verona Brown*
Viridian*
Yellow Ochre*
Yellow Ochre, Pale*
Zinc White*

NOTE. The pigments marked with asterisks may be considered as absolutely permanent under all ordinary conditions of Oil Painting. The rest are good sound colors, but their permanence depends, to a certain extent, on the conditions of their use and exposure. They may, in fact, be regarded as practically permanent under careful treatment.

† Permanent on exposure to light, etc., but sullied in an atmosphere containing sulphuretted hydrogen, and yellowed by reaction with the oil medium.

†† Permanent on exposure to light, etc., but sullied in an atmosphere containing sulphuretted hydrogen.

CLASS II—MODERATELY PERMANENT COLORS

Alizarin Green
Alizarin Orange
Alizarin Yellow
Asphaltum
Bitumen
Bone Brown
Brown Pink
Cadmium Yellow, Extra Pale
Caledonian Brown
Cassel Earth
Chinese Orange
Chrome Green, No. 1*
Chrome Green, No. 2*

Chrome Green, No. 3*
Chrome Deep*
Chrome Lemon*
Chrome Orange*
Chrome Red*
Chrome Yellow*
Cinnabar Green, Light*
Cinnabar Green, Mid*
Cinnabar Green, Deep*
Emerald Green†
Indian Lake
Indian Yellow
Kings' Yellow*

Malachite Green†
Malachite Green, No. 2†
Primrose Yellow
Purple Lake
Rembrandt's Madder
Rose Doré
Rubens' Madder
Sap Green
Strontian Yellow
Sepia
Vandyke Brown

CLASS III—FUGITIVE COLORS

Burnt Carmine
Carmine
Carmine, No. 2
Citron Yellow††
Crimson Lake
Gamboge
Geranium Lake

Green Lake, Light
Green Lake, Deep
Indigo
Italian Pink
Magenta
Mauve
Mauve, No. 2

Olive Green
Olive Lake
Prussian Green
Verdigris**
Violet Carmine
Yellow Carmine
Yellow Lake

* These stand light, oxygen, and moisture fairly well, but are reduced by the oil of the medium, and by the action of sulphuretted hydrogen.

† Permanent to light, etc., but darkened by sulphuretted hydrogen, the change being facilitated by the slight solubility of these pigments in oil.

†† Reduced and turned green in contact with an oil medium or with sulphuretted hydrogen.

** Soluble in oil, and blackened by sulphuretted hydrogen. In every way a bad color under the present conditions of oil painting.

N.B. Some of these fugitive colors are often supposed to be much more fleeting in ordinary daylight than is really the case. Thus, Carmine, Carmine No. 2, Crimson Lake, Gamboge, the Green Lakes, Indigo, Italian Pink, Olive Lake, and Yellow Lake experience very little alteration, even after two or three years' exposure, and without any protection whatever from varnish.

Geranium Lake is the most fugitive oil color made, and fades quickly in an ordinary wall-light. The Mauves and Magenta become redder in hue and have a tendency to blacken, but do not fade rapidly. Purple Lake and Indian Lake also redden considerably, but otherwise stand tolerably well. Olive Green becomes bluer. Verdigris becomes much yellower. Violet Carmine turns quite black.

The above remarks apply, of course, only to the colors exposed *per se*. When, however, they are diluted with Zinc White or White Lead, in the formation of tints, the changes are, as a rule, greatly accelerated.

Printed in Great Britain